TREASURES IN THE VIRGINIA MUSEUM

TREASURES
IN THE
VIRGINIA MUSEUM

The publication of this special book has been made possible by the Fellows of the Virginia Museum.

Standard Book Number, 0-8139-0600-8
Library of Congress Catalog Card Number, 74-80700.
Virginia Museum, Boulevard and Grove Avenue,
Richmond, Virginia 23221.

Foreword

One of Webster's definitions of pride is "a delight or elation arising from some act or possession." This appropriately conveys the feeling that inspired us to undertake this publication. There have always been in the collection of the Virginia Museum certain outstanding possessions of which we all have been understandably proud, and in the past few years this list of "gems" has expanded appreciably. Thus it is a simple, genuine feeling of pride that underlies our reasons for publishing *Treasures in the Virginia Museum.* We hope you will enjoy sharing these varied treasures with us.

I would like to note that the book would not have been possible without the encouragement and financial assistance of the Fellows of the Virginia Museum, a philanthropic group that each year assists us in a special project. At their annual meeting in 1973, the Fellows voted to sponsor publication of a book describing and illustrating some of the Museum's favorite treasures, and for this generosity we—the trustees, staff, and membership—are most grateful. The 1972-73 membership roster of the Fellows is printed on the following page.

James M. Brown, Director

The Fellows of the Virginia Museum, 1972-73

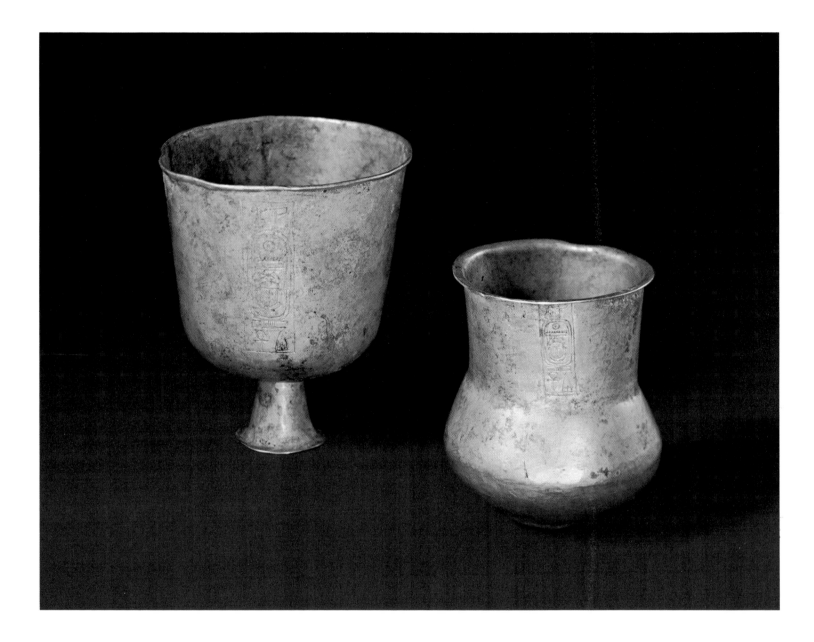

Beaker and Goblet

Egyptian (New Kingdom), XVIII Dynasty, 1494-1479 B.C.
Gold, beaker 2⅝ inches high, goblet 3⅜ inches high
Williams Fund, 1963

A number of gold vessels, including some identical to this beaker and goblet, were discovered in 1916 in the so-called Tomb of the Three Princesses near Deir el Bahari. The Museum's two pieces almost certainly belong to the same find, which constituted a treasure belonging to three of the lesser wives of the Pharaoh, Thotmose III. The Pharaoh's cartouche, "the good god, Men-Kheper-re, to whom life is given," is engraved on their sides. These vessels undoubtedly formed part of a sumptuous table service, and signs of wear indicate that they were not simply burial objects but were actually used in life by their owners.

Seated Scribe

Egyptian, Late Period (Saite), XXVI Dynasty, 664–610 B.C.
Alabaster, 29½ inches high
Williams Fund, 1951 and 1964

The upper half of this impressive statue was acquired in 1951, the lower half thirteen years later, after having been dramatically rediscovered by Bernard Bothmer, Curator of Ancient Art at the Brooklyn Museum. On the shoulders are inscribed the cartouches of the Pharaoh, Psamtik I; on the base is an elaborate inscription referring to the subject, Sema-tawy-tefnakht, a governor-general and intelligence officer of the Pharaoh who is recorded as commander of the grand flotilla that brought the Pharaoh's daughter, Nitocris, to Thebes in 656 B.C.

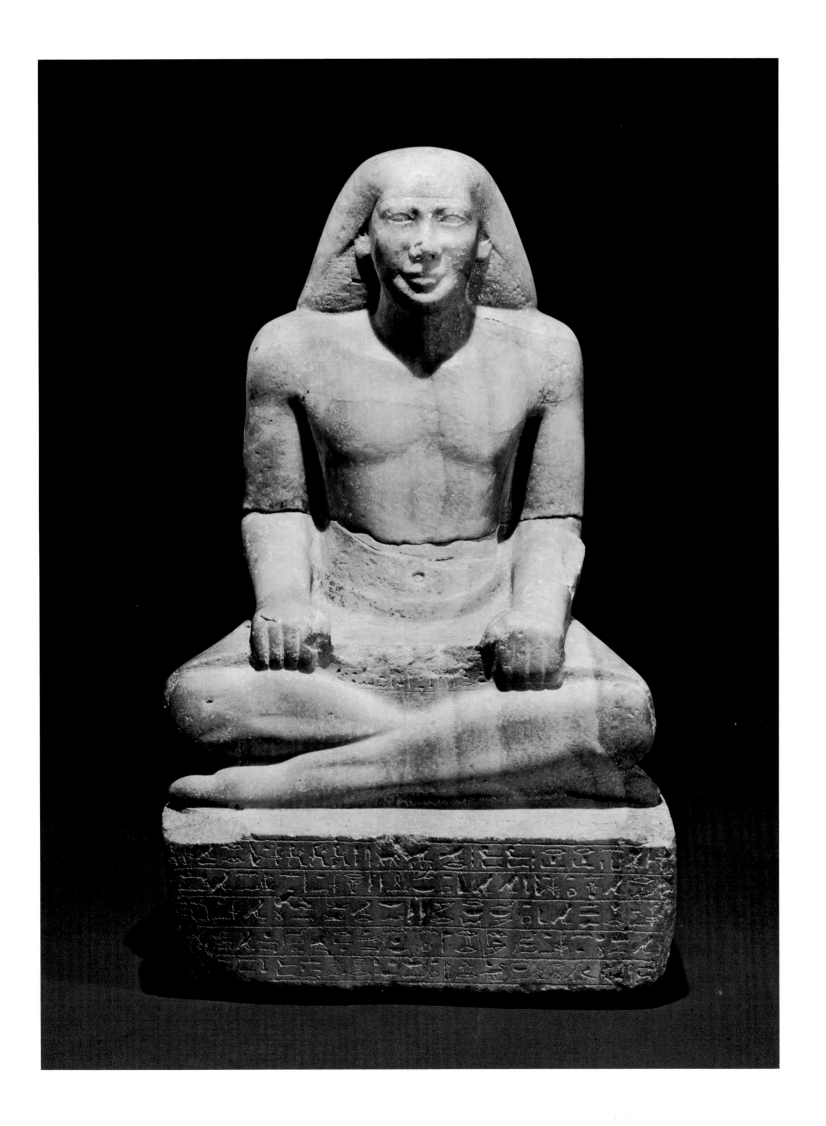

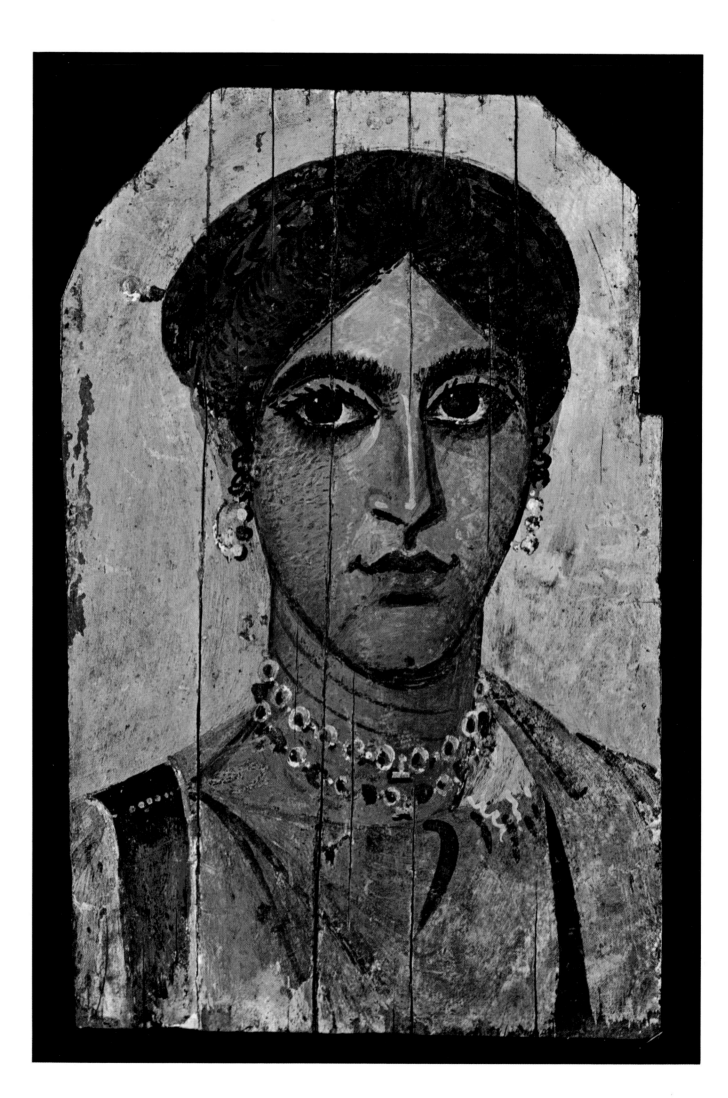

Portrait of a Woman

Egyptian-Roman, early 4th century A.D.
Encaustic on wood panel, 13 inches high by 8¼ inches wide
Williams Fund, 1955

The Roman conquest of Egypt brought a virtual end to monumental sculpture. Instead of portraits in stone, effigies in stucco and encaustic paint were employed to memorialize the dead. This forceful portrait, conveying a sense of withdrawal and psychological reserve characteristic of the troubled period of Constantine the Great, from which it dates, was originally inserted in the exterior wrapping of the young woman's mummy. It was found in the Fayum, a fertile oasis south of Cairo from which the majority of these portraits derive.

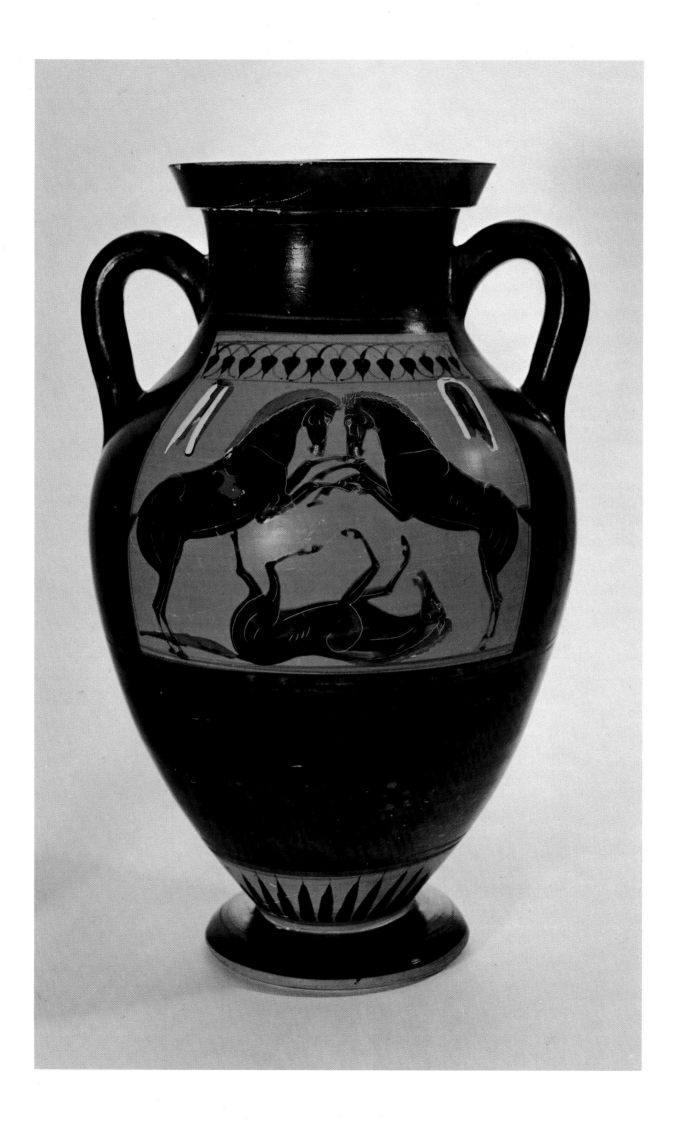

Black-Figured Amphora

Greek, circa 535 B.C.
Terra-cotta, 15¼ inches high
Williams Fund, 1962

The elegant clarity of the drawing in the scenes painted on this vase is characteristic of the style of the Swing Painter, to whom the late J. D. Beazley, principal authority on the subject, attributed the vase. The Swing Painter was not only prolific (well over 100 vessels are attributed to him), but also was extremely varied and inventive in his subject matter. On one side a quadriga, shown with its horses in full face, tensely awaits an imminent departure. More unusual is the other scene, which depicts a stallion and a mare fighting over a fallen horse. It has been suggested that a parody is intended: Achilles and Penthesilea, the Amazon Queen, in combat over a wounded comrade.

Nike Earring

Greek, 350–300 B.C.
Gold, 2¼ inches high
Williams Fund, 1964

Nike was a winged female associated in Greek mythology with her male counterpart, Eros, as a daemon of both love and death. In the Museum's earring she is in the act of alighting. The figure, suspended from a complexly wrought rosette, once held a wreath in her right hand. In conception it is an image of startling energy and in execution a tour de force of the goldsmith's art. This earring is very close to one in the Istanbul Museum and is related to the Boston Museum's superb *Nike Driving a Chariot*.

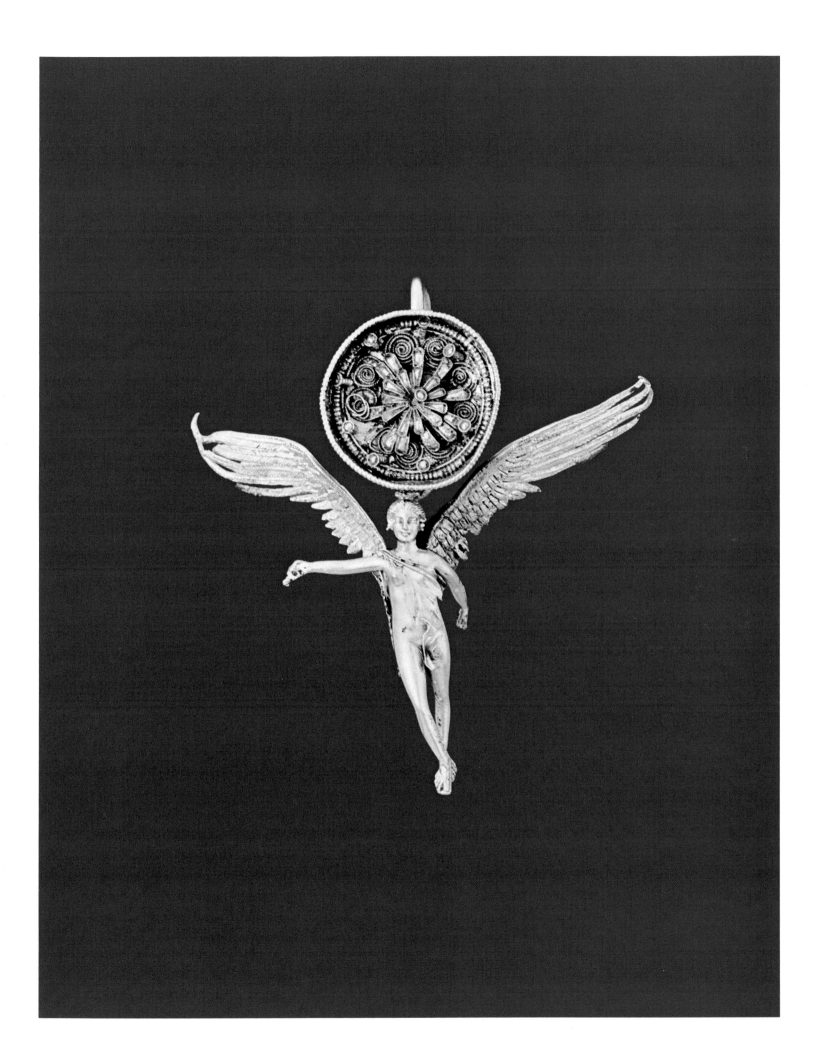

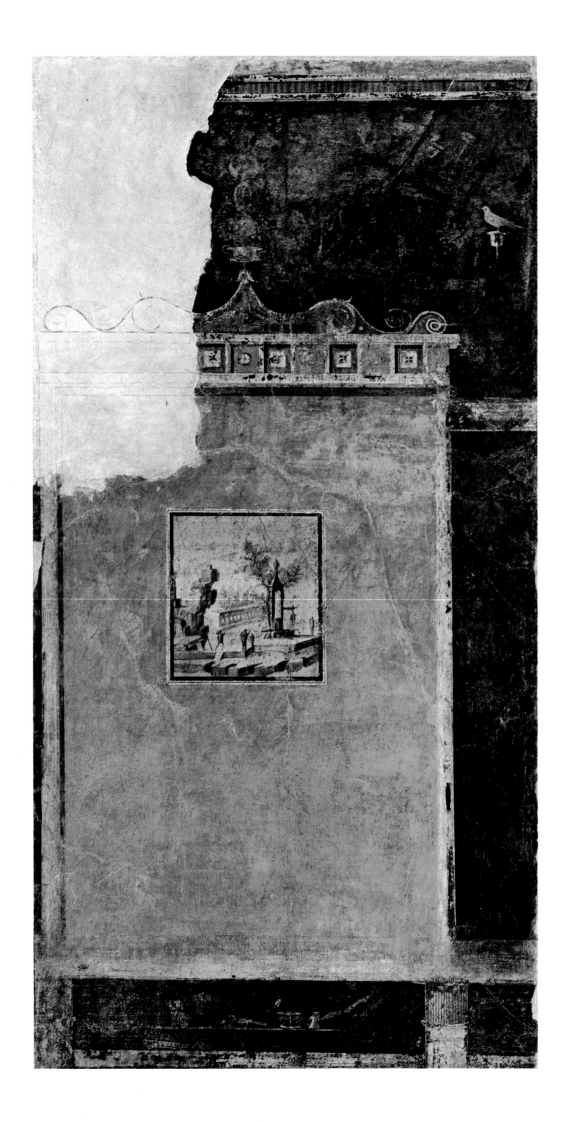

Wall Painting

Roman, 1st century A.D.
93⅜ inches high by 45¾ inches wide
Williams Fund, 1966

This wall panel is from a villa near Boscoreale, owned in the 1st century
A.D. by a certain N. Popidius Florus. It is a work of the so-called Pompeian
Third Style, which is characterized by representations of slender archi-
tectural elements disposed in an airy, decorative manner against a black
ground. Also characteristic of the Third Style is the idyllic landscape with
its ghost-like figures and casual arrangement of picturesque, ethereal forms
from nature and architecture. A number of other panels from the same villa
are owned by the J. Paul Getty Museum in Malibu; three of these are from
the same room as the Virginia Museum's.

Caligula

Roman, 1st Century A.D.
Marble, 82¾ inches high
Glasgow Fund, 1971

Due to the systematic efforts to eradicate the memory of Caligula after his
death in 41 A.D., portrait statues of this Emperor are extremely rare. Only
two full-scale marble representations are known, a somewhat crude,
provincial work recently found in Gortyn, Crete and the Museum's version.
The latter—in its vitality of conception, fluid virtuosity, and, above all,
serene idealization—is a superlative example of sculptural production
in Rome toward mid-century.

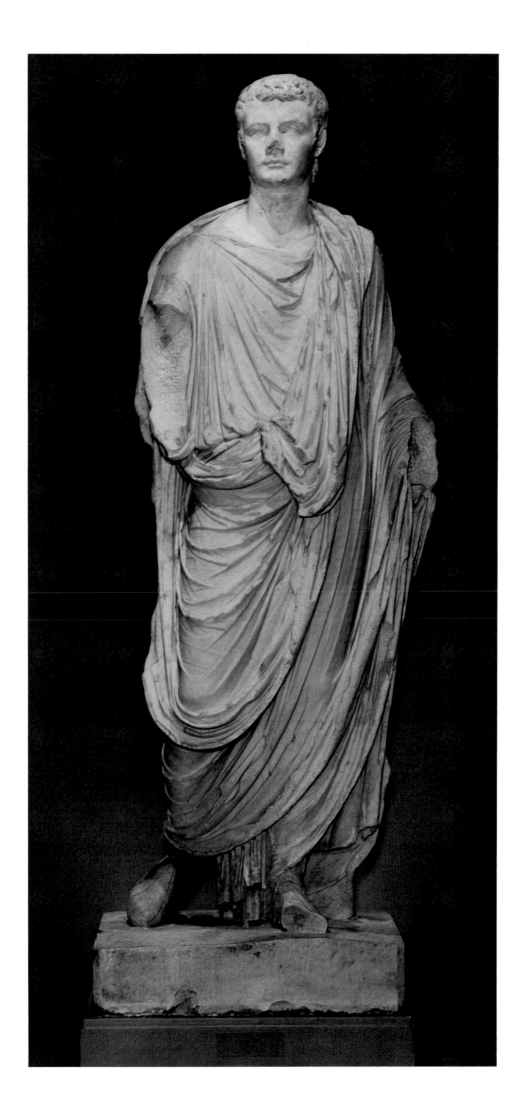

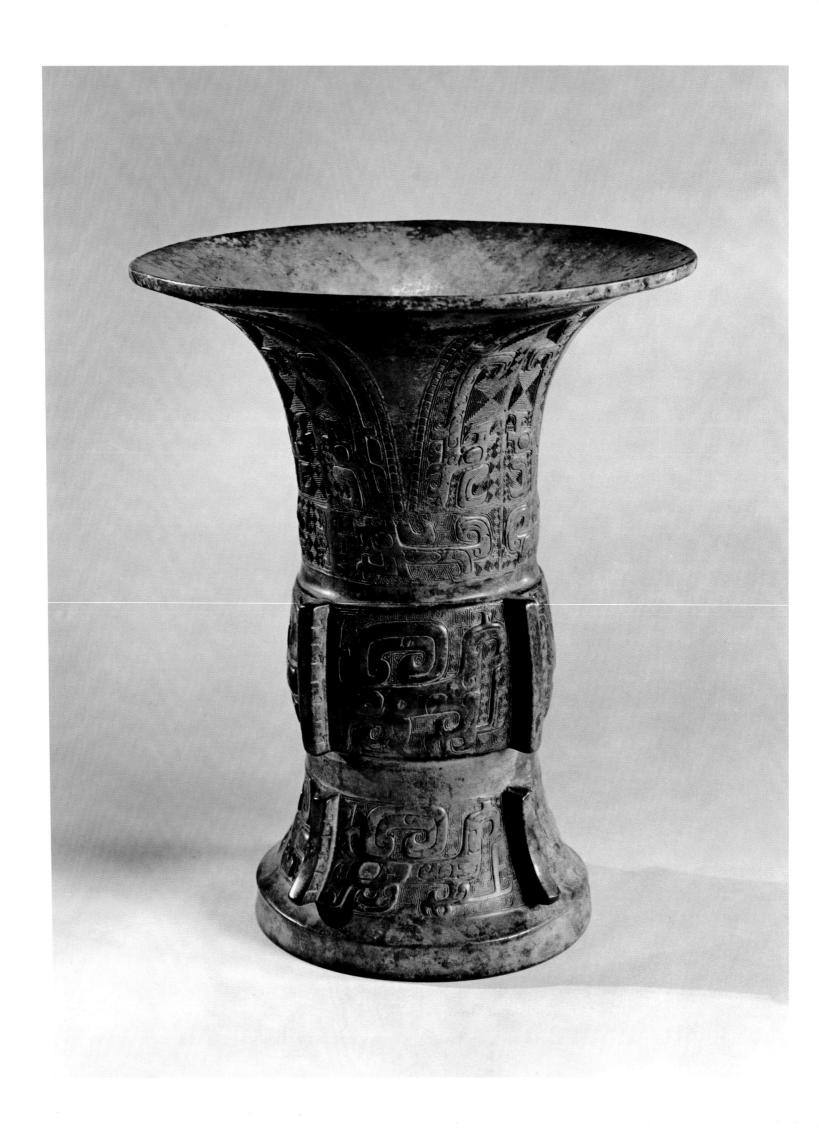

Ancient Bronze

Chinese, Shang Dynasty, 1523-1027 B.C.
Bronze, 12 inches high
Williams Fund, 1957

The ritual bronzes of the Shang Dynasty mark the high point of early
Chinese art. In their technical perfection and the magisterial force of their
conception they were never surpassed in later times. The vessel illustrated,
a stout wine beaker traditionally called a *tsun,* is one of seventeen bronzes
owned by the Museum. The three horizontal zones of its surface are densely
decorated with various motifs on a ground of tight spirals: in the lower and
middle zones, masks of the *t'ao-t'ie,* a mythical monster with protruding eyes
and C-shaped horns; on the neck, beaked, antithetical dragons surmounted
by broad blades, each enclosing a pair of inverted dragons.

Archaic Jade

Chinese, Shang and Chou Dynasties, 1523–256 B.C.
Williams Fund, 1959

These five pieces are part of a relatively large group of archaic jades in the Museum's collection. Early Chinese jade shares much of the austere beauty of the early bronzes; their functions were also similar, for both jade and bronze objects were intended for ritual use. The spatula-shaped piece with a tiger at its summit is presumed to be a ritual spoon ornament (4 inches long). The tiger motif itself and the bird and animal in the talismanic plaque shown here (3½ inches long) are drawn from the inexhaustible formal repertory created by the Shang and Chou jade carvers. The disc, or *pi* (5½ inches in diameter), was considered a symbol of the sky, and the knife blade (16½ inches long) and dagger ax with turquoise-inlaid bronze handle (11¾ inches long) may have served as badges of rank.

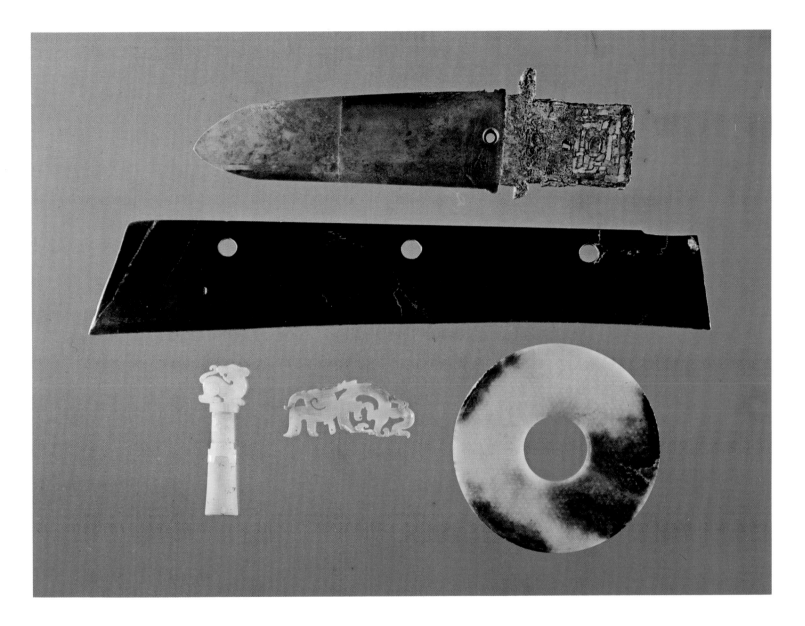

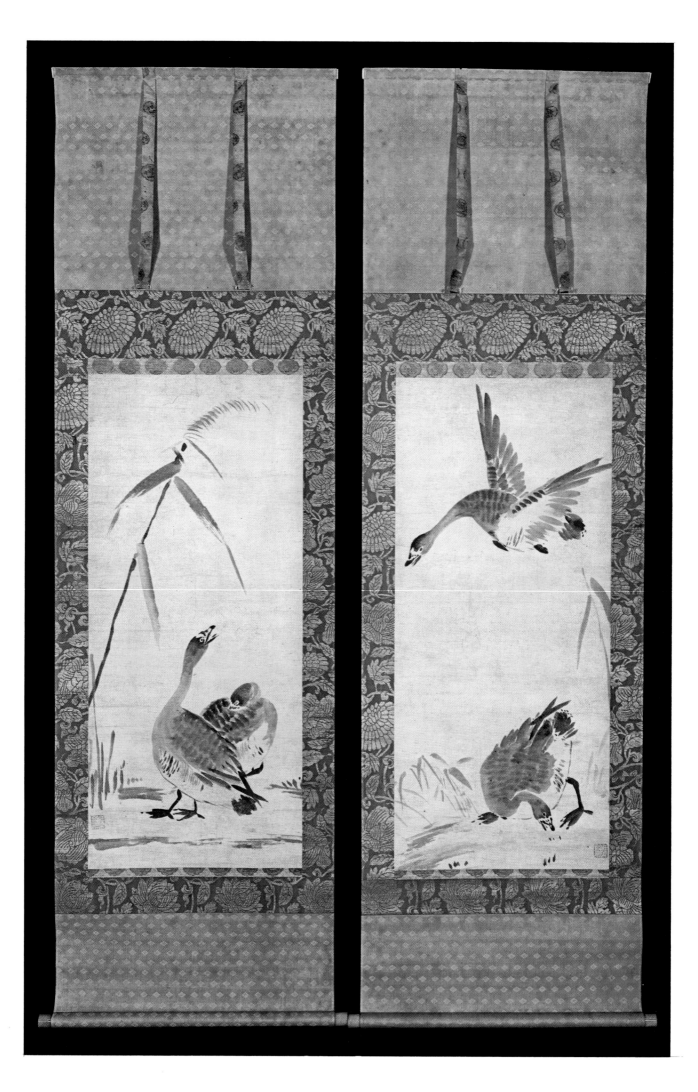

Reeds and Geese

Tesshū Tokusai, Japanese, died circa 1366
Ink on paper, each 71⅝ inches high by 23¼ inches wide
Williams Fund, 1973

Monochrome ink painting *(suiboku-ga)* was introduced into Japan from China by Japanese Zen monks, many of whom visited the mainland in the thirteenth and fourteenth centuries. Tesshū Tokusai was in China for several years before 1341. While there, the Emperor Shun Ti conferred on him the honorary title "Great Master of Universal Wisdom," and on his return to Japan he served as abbot of a number of monasteries. *Suiboku-ga* was popular with Zen artists, its flexibility and expressive capacities explaining its peculiar appeal. Tesshū was one of its most accomplished practitioners, and the Museum's scrolls are among the finest of the few works by him which exist today.

The Sun God Sūrya

Central India, 9th century A.D.
Sandstone, 55½ inches high
Anonymous Gift, 1968

In the ninth century the cult of the sun god rivaled those of the great Hindu gods Vishnu and Siva. The cult borrowed much from earlier foreign invaders, in particular the Kushans, a people originally from China. This fact is curiously reflected in the exotic garments of the Museum's Sūrya, particularly his padded boots and richly ornamented tunic. Completely consonant with the theme is the figure's sense of firm, unequivocal presence and the geniality and radiance of his expression.

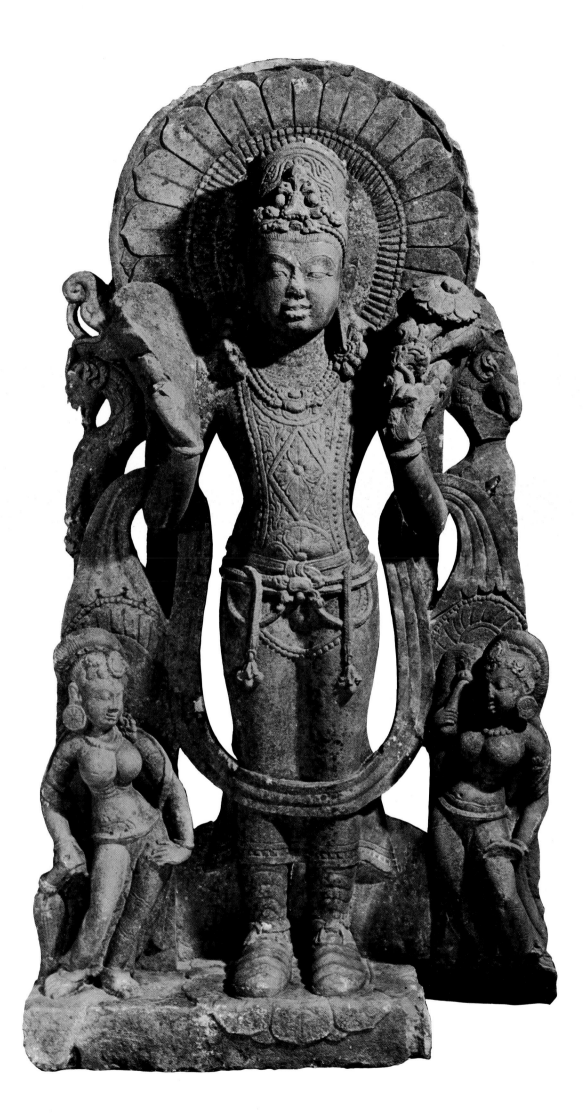

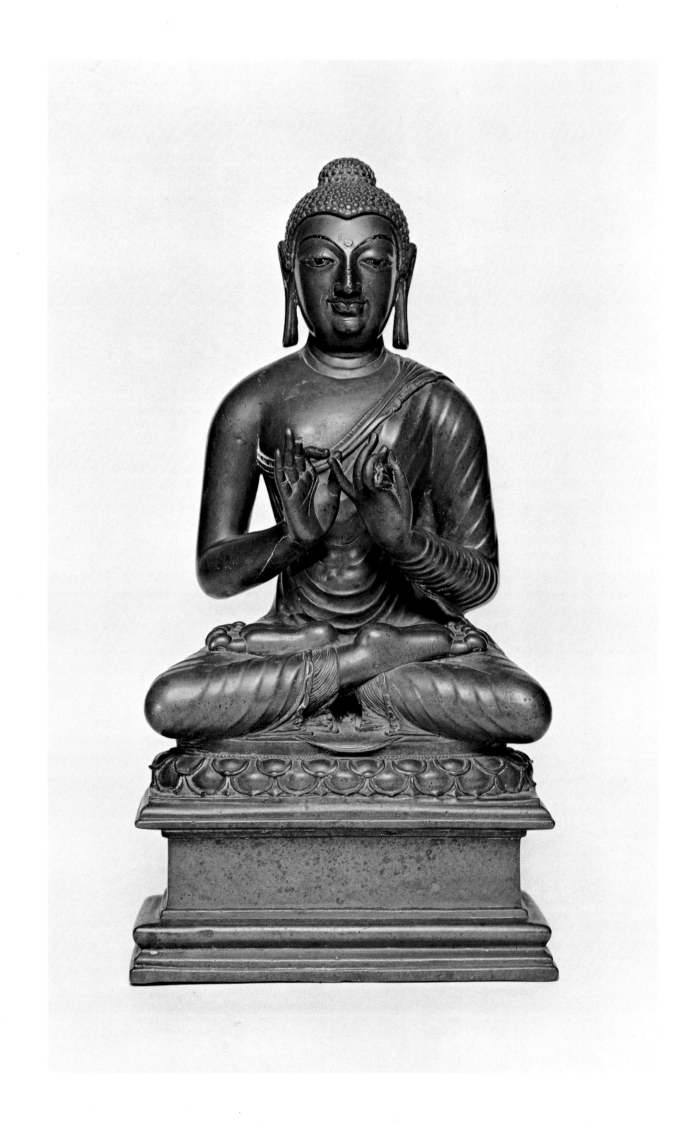

Seated Buddha

Kashmir, circa 10th century A.D.
Bronze, 16¾ inches high
Anonymous Gift, 1968

The Buddha is seated in the *dhyāna* position on a double row of lotus petals.
His hands are in the teaching gesture *(Dharmacakra pravratana-mudrā).* The
figure conveys an overwhelming sense of vitality through its combination of
monumental plasticity and infinitely subtle linear refinement. It is a bronze
equalled by few sculptures from Kashmir.

Siva Nataraja

South Indian, 11th to early 12th century A.D.
Bronze, 39 inches high
Williams Fund, 1969

The periodic destruction and re-creation of the universe was the function of Siva, and as the Nataraja, or Lord of the Dance, he symbolically enacts this process. Two elements—the flames leaping from the halo encircling Siva and the small skull on his headdress—connote destruction, while the drum in one of his right hands is emblematic of creation. Almost all accessory detail refers to one or the other of these opposed activities, and both tendencies are dynamically synthesized in the pulsating energy of the dancing god.

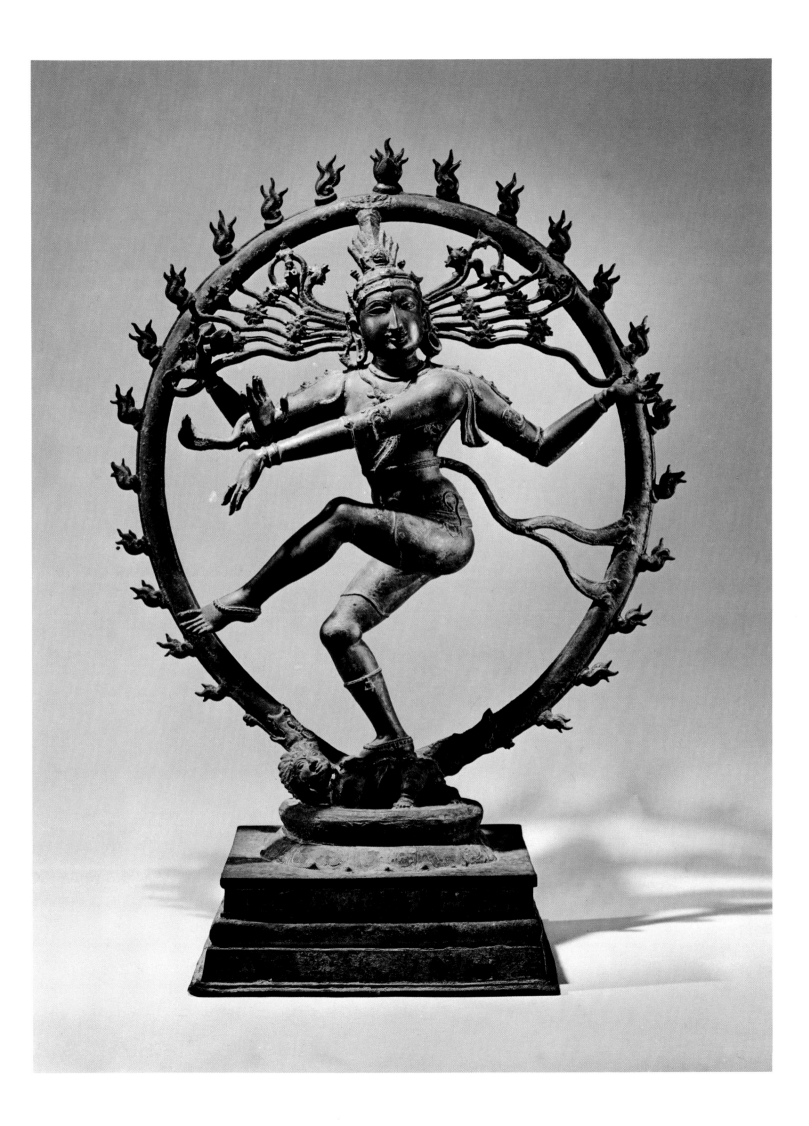

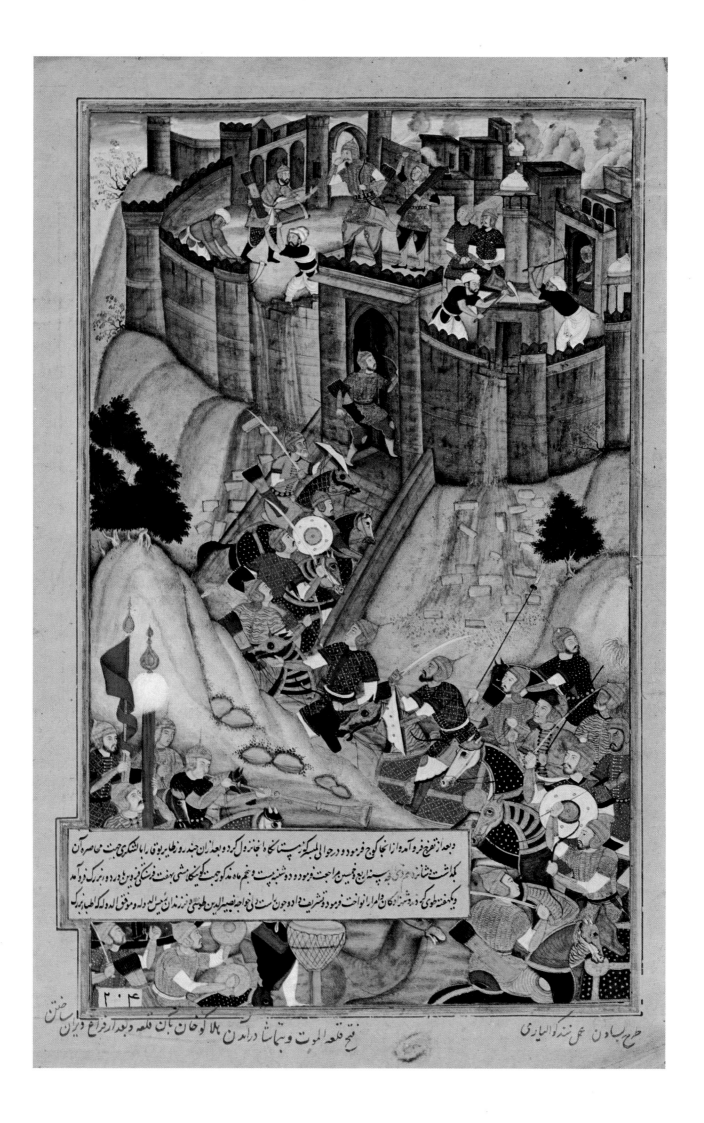

Akbar-nāma

Indian, circa 1600
Gouache on paper, 13¼ inches high by 8¼ inches wide
Anonymous Gift, 1968

This is a page from what is considered the most impressive and successful of the various illustrated copies of the *Akbar-nāma*, which was the history of Akbar, the great Mogul emperor who lived from 1542 to 1605. The majority of the pages from the manuscript are owned by the Victoria and Albert Museum. The *Akbar-nāma* is an account of the emperor's reign down to the year 1601 and was written in Persian by the historiographer Abul Fazl. Scenes of battle and the storming of citadels, as in the Museum's page, abound.

Jaguar

Peruvian, circa 400 B.C. to 100 A.D.
Gold, 4½ inches long
Williams Fund, 1959

This very early example of pre-Columbian goldwork, a real triumph of plastic vitality, is from the Mochica culture of the north coast of Peru. It is composed of nine separate sections formed by hammering, probably over a stone matrix, and joined by a sophisticated method of soldering and sweat welding. Several other gold jaguars are known and are so close to the Museum's in dimensions and design that it is likely they were made by the same craftsman. Small holes in the paws suggest that originally they were suspended from a cord to form a necklace.

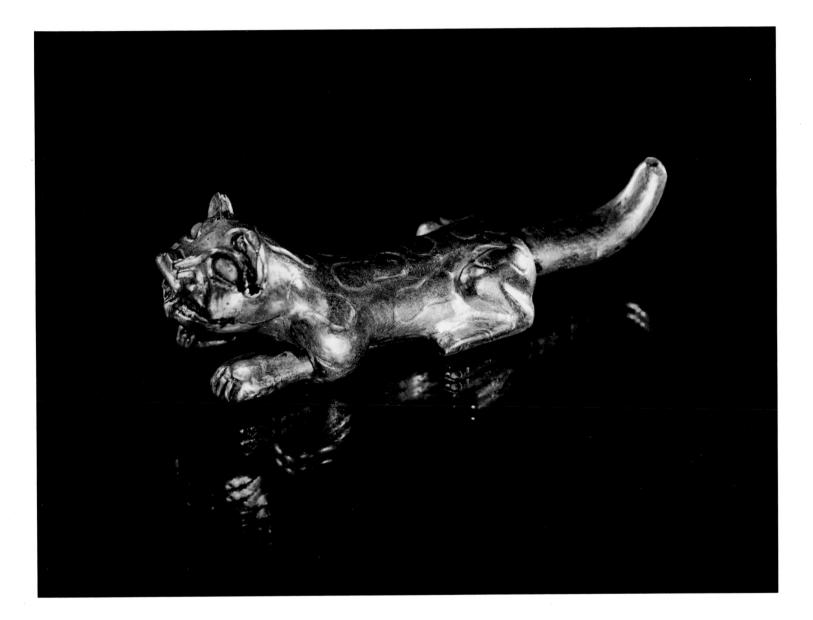

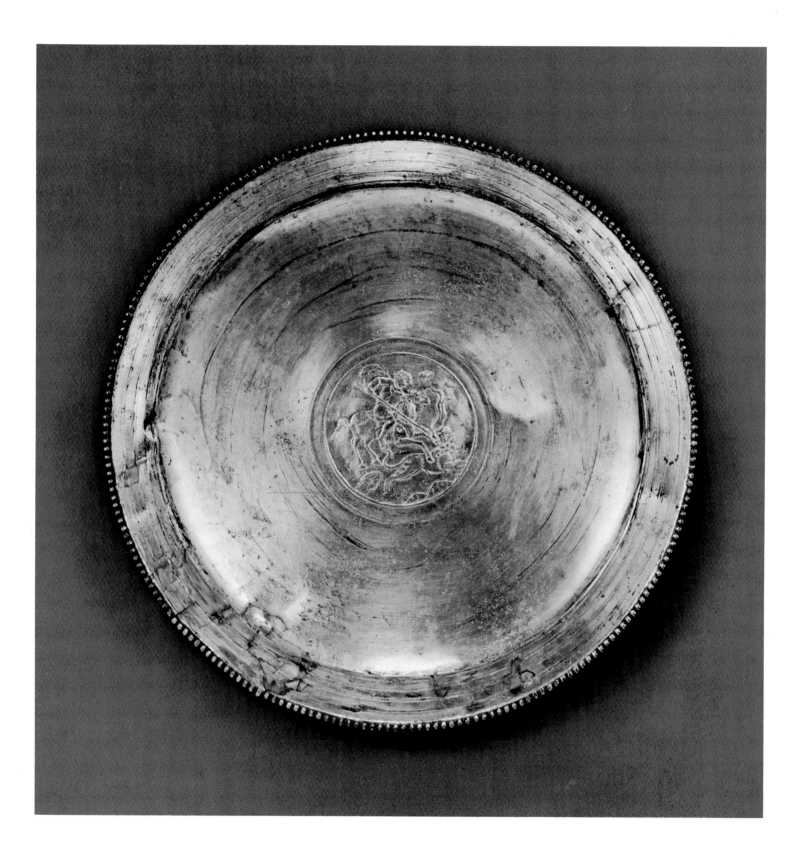

Hunting-Scene Plate

Byzantine, 4th century
Silver, 17 inches in diameter
Williams Fund, 1966

This sumptuous plate is one of six pieces making up a treasure discovered
in northern Syria. The other five pieces include three spoons, a hunting
horn, and a bowl. The Museum's Byzantine-Medieval Advisor, Dr. Marvin
C. Ross, has pointed out that the plate is the only one of its kind in a public
collection in this country. In an article in the Museum magazine *Arts in Vir-
ginia* (Volume 8, Numbers 1–2), Dr. Ross related the cast relief hunting
scene at the center to Syrian mosaics of the same period, especially those
from the famous excavations at Daphni, near Antioch.

Reliquary

Byzantine, 10th century
Gold and enamel, 1½ inches high by 1¼ inches wide
Glasgow Fund, 1966

This *panaghia,* or pendant reliquary, is an exceptionally fine example of
Byzantine cloisonné enamelwork of mid-tenth century. This is the date of
the earliest plaques on the celebrated Pala d'Oro in Venice and our pendant,
like them, was made in Constantinople. On the front, Christ is flanked by
busts of Peter and Paul, and on the back Luke and John flank the orant Vir-
gin. The interior is provided with cellular compartments which once con-
tained relics.

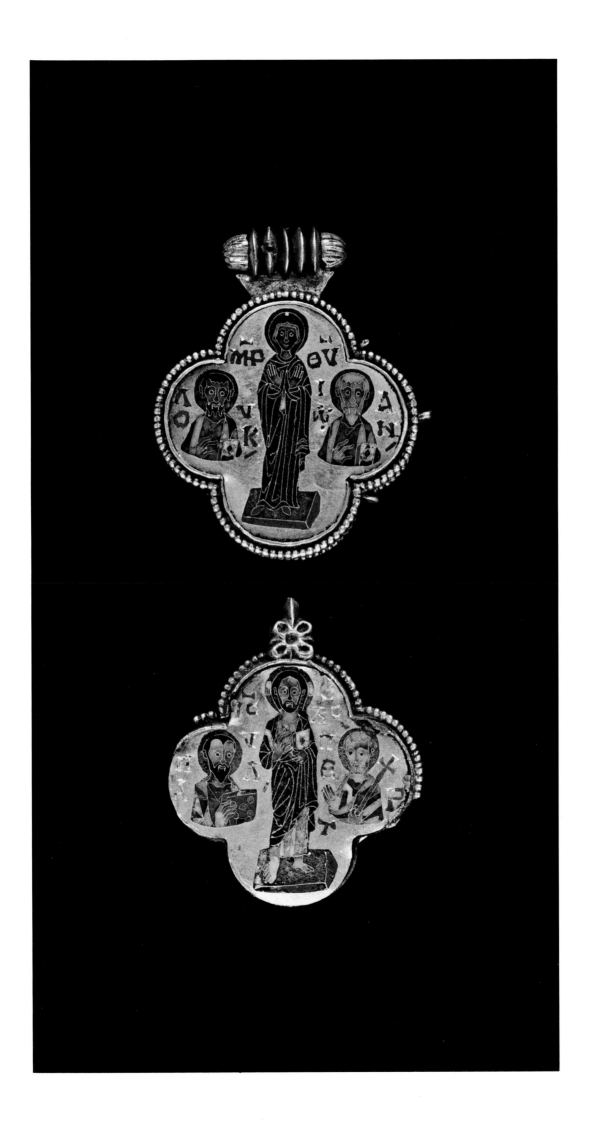

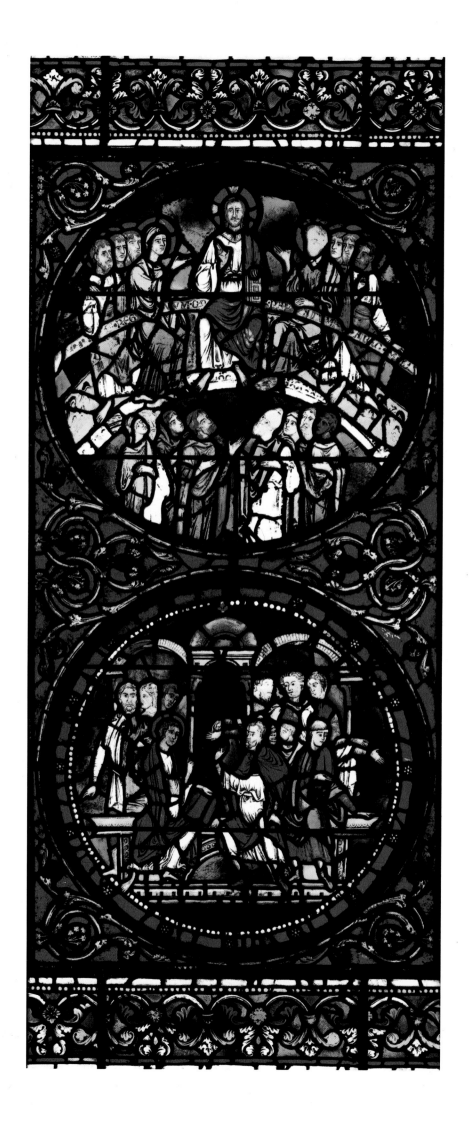

Stained-Glass Window

English, circa 1200
92 inches high by 36½ inches wide
Williams Fund, 1969

One of three pieces of stained glass from Canterbury Cathedral in American public collections, this window is considered the finest example outside Canterbury itself. It was removed from the Cathedral before 1852 and was in private hands from at least early in this century. In her recent study of this window (*Arts in Virginia*, Volume 13, Number 2), Madeline H. Caviness has convincingly demonstrated that the upper medallion, identified as *Jesus Reading in the Synagogue*, and the lower, *The Last Judgment*, were originally in windows from quite different parts of the Cathedral. Both date from the period 1180–1210. *Jesus Reading* represents the earlier, late-Romanesque part of that phase, and the *Last Judgment*, with its intimations of the nascent Gothic, the years closer to 1210.

Mirror Back

French, 14th century
Ivory, 4⅝ inches high by 4⅝ inches wide
Williams Fund, 1969

Mounted knights jousting before a turreted castle with trumpeting heralds at either side might seem a strange subject for a lady's mirror back. In this activity, however, the knight's aim was to win the heart of his lady, one of those seen here on the castle wall. The code of chivalry demanded such ritual combat, and scenes of jousting or of knights playfully storming the "castle of love" are common on both mirror backs and marriage caskets. This ivory represents the highest level of Parisian ivory-carving toward mid-fourteenth century.

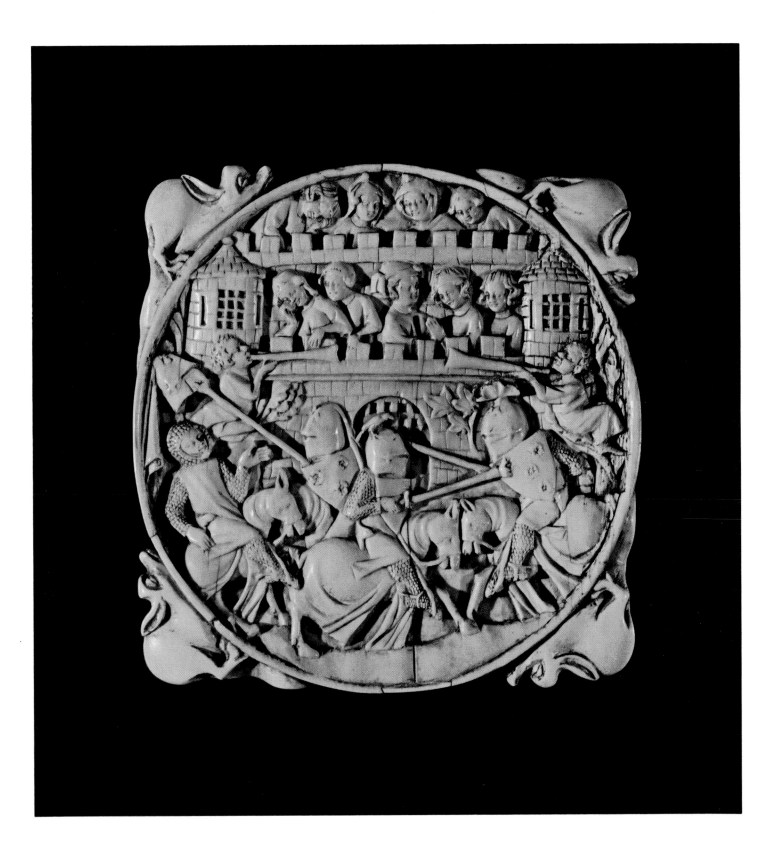

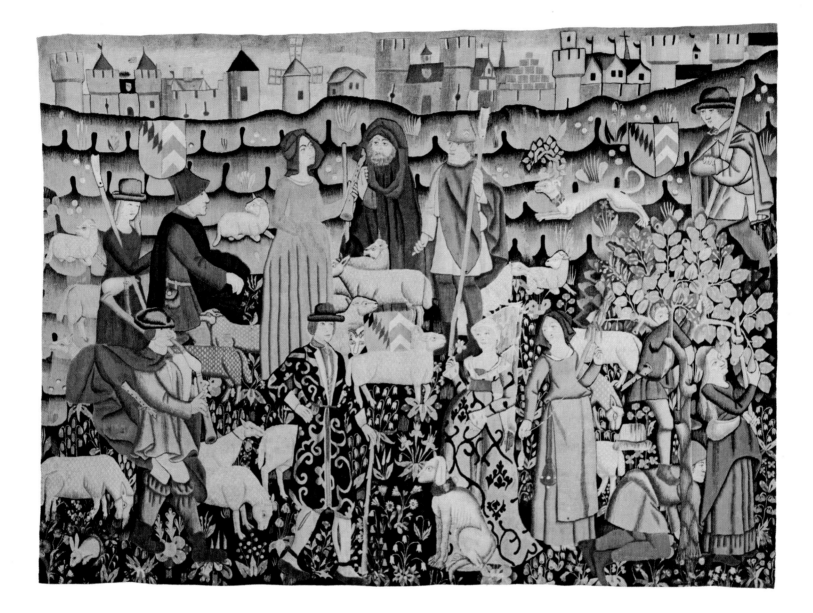

The Marriage of Rigault d'Oureille

French, circa 1475–1490
Tapestry, 98 inches high by 134 inches wide
Williams Fund, 1954

Fifteenth-century French tapestries are rare. The date of this one cannot be fixed precisely, but the armorial shields at the center and to the right and left identify the lord and lady in the foreground as the youthful Rigault d'Oureille (1455–1517) and his second wife, Catherine de Rancé. Rigault was Seneschal of Gascony and Master of the Royal Household under Louis XI. The secondary figures offer a virtual compendium of types from French rural life of the period, and the distant horizon bristles with the buildings of Rigault's hometown, Villeneuve-Lembron in Auvergne.

Crèche

Flemish, 15th century
Silver, 10½ inches high by 9¾ inches wide
Williams Fund, 1971

A specialty of southern Flanders, small-scale cradles, or *crèches*, with the sleeping Christ Child were in vogue from about 1300 until mid-sixteenth century. The earliest were made as devotional objects for monastic cells; the later ones tend to be larger and more elaborate and were displayed on chapel altars. Most of these crèches were made of wood. The Museum's is extremely rare (only one other in silver is known), and is a splendid example of late Gothic craftsmanship.

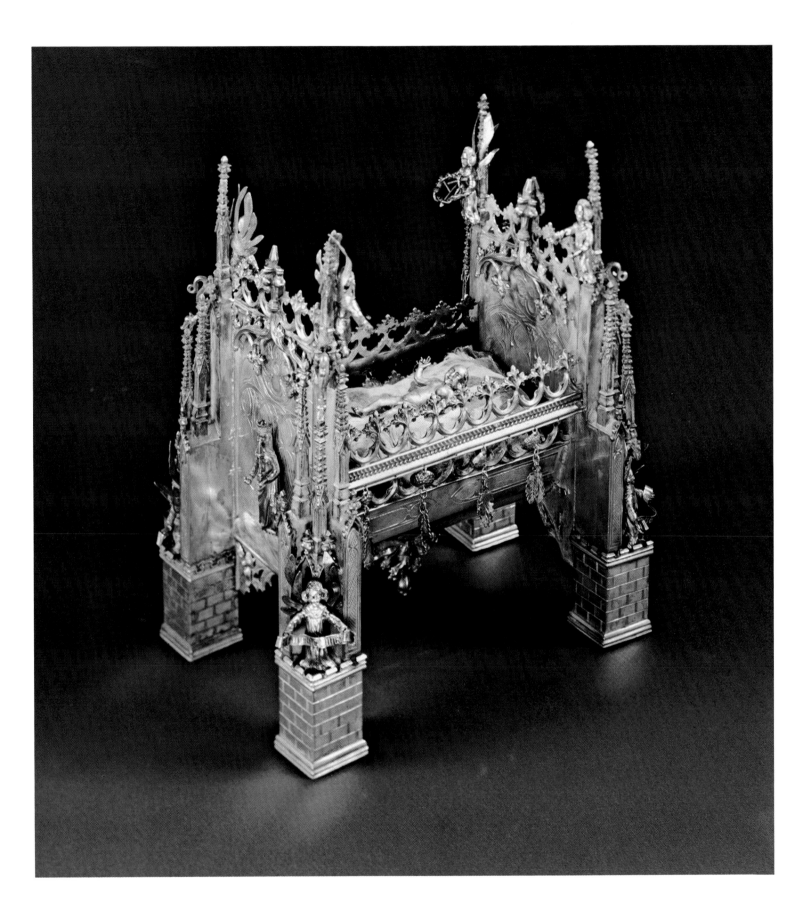

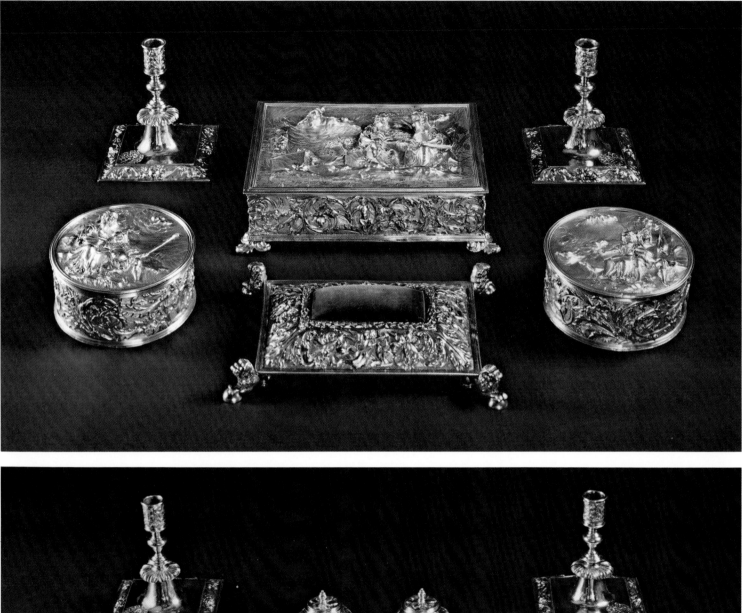

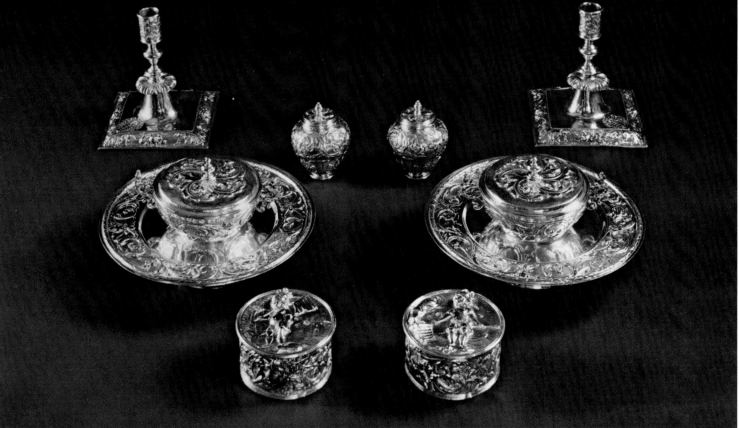

Toilet Service

English (London), 1679
Silver
Gift of Albert P. Hinckley, Jr., 1973

Elaborate toilet services designed for use on the dressing table were a seventeenth-century phenomenon. The English diarist John Evelyn describes the Queen's "rich toylet in her dressing roome...all of massie gold." The service given by Mr. Hinckley is a magnificent example of Charles II silver, remarkable especially for its chased and high-relief repoussé designs. It bears the London hallmark of 1679, an unidentified maker's mark of a goose in a dotted circle, and the impaled arms of the Brownlow and Sherrard families.

Apotheosis of Louis XIV

French, late 17th century
Tapestry, 192 inches high by 108 inches wide
Gift of the Estate of Regina V. G. Millhiser, 1965

Louis XIV is shown being crowned with the laurel wreath of victory, seated in a chariot and surrounded with the weapons and trophies of war. In keeping with the regal theme are the monumental scale, the composition (utilizing the full apparatus of Baroque design), and the fabric itself (with its lavish use of gold and silver thread). The *Apotheosis* originally formed part of a series of eight tapestries devoted to *The Conquests of Louis XIV*, based on cartoons by Jean-Baptiste Martin, the Elder (1659-1735), who succeeded van der Meulen as Louis XIV's official painter of battles in 1690. The *Conquests* series was woven at Beauvais at about the same date.

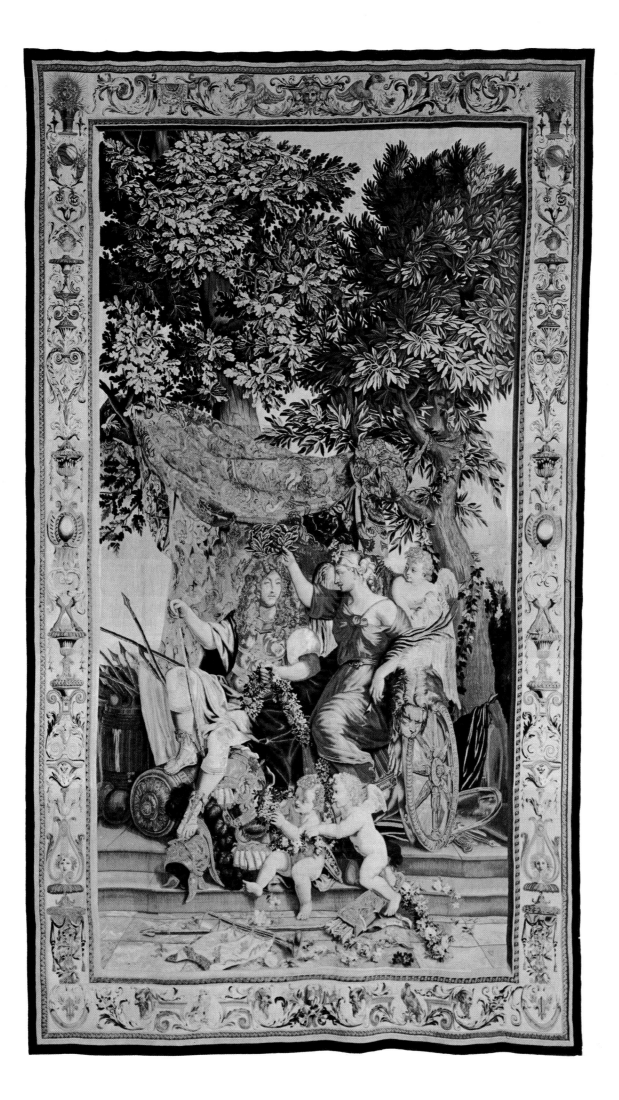

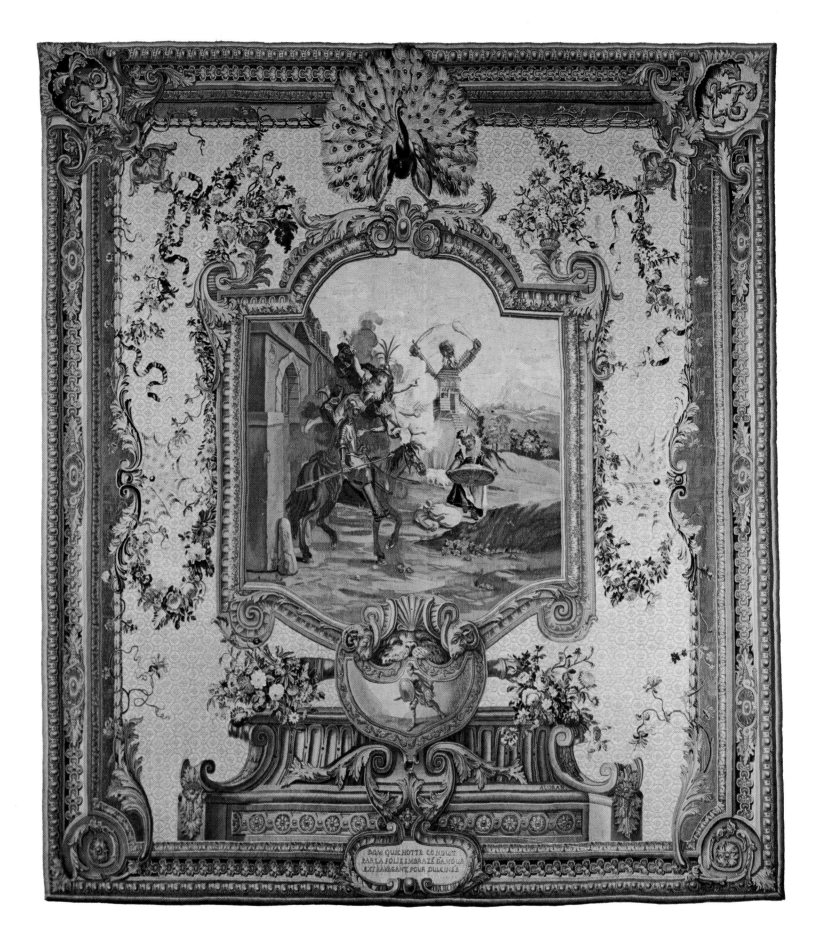

DON QUICHOTTE CONDUIT
PAR LA FOLIE EMBRAZÉ D'AMOUR
EXTRAVAGANT POUR DULCINÉE

Don Quixote

French, mid-18th century
Tapestry, 142 inches high by 125 inches wide
Williams Fund, 1964

This is one of six tapestries owned by the Museum recounting the story of Don Quixote. It is the first in the series and depicts the Don setting forth on his adventures. The complete series comprised twenty-eight tapestries. The subject panels were designed by Charles Antoine Coypel (1694–1750) and the decorative surrounds *(alentours),* which vary from set to set, by various other artists. Woven at the Gobelins factory many times in the eighteenth century, the series was tremendously popular; in terms of narrative liveliness and sheer gorgeousness of decorative effect, it is unsurpassed in its period. The Museum's six are from a set woven for the royal Chateau of Marly and later owned by the Empress Eugénie.

Tureen with Platter

French (Sèvres), 1773
Porcelain, tureen 12¾ inches long by 8 inches wide,
platter 20¼ inches long by 16¼ inches wide
Gift of The Andrew W. Mellon Foundation, 1972

This elegant soup tureen *(soupier)* is part of a banquet service manufactured at Sèvres in 1773. Besides the date mark it bears the marks of two gilders—Etienne-Henri Le Guay, the Elder, and Baudouin, the Elder—and an unidentified painter's mark. The set is large, numbering over 150 pieces, and many different painters and gilders were engaged in its decoration.

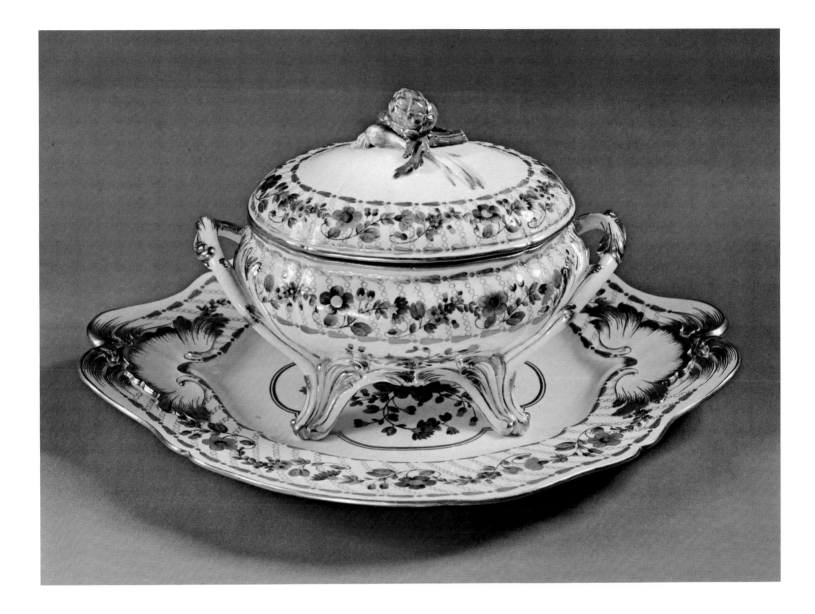

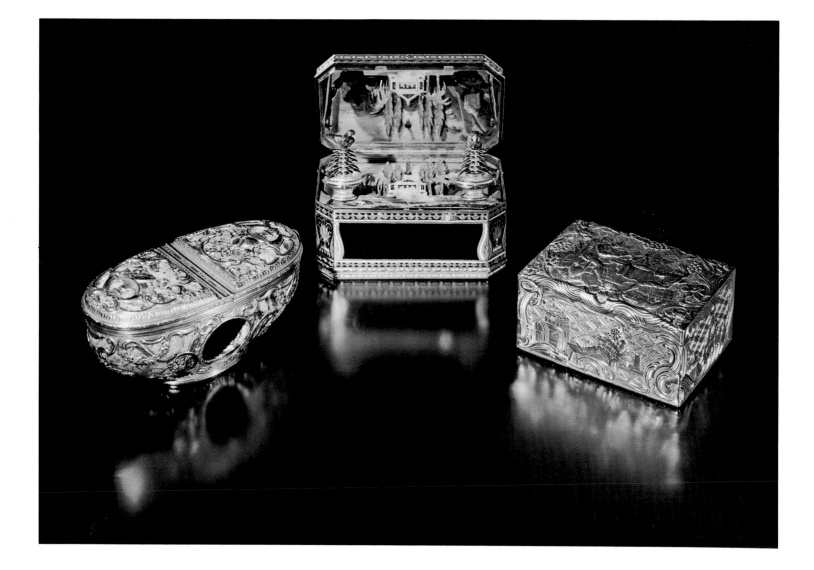

Snuff and Mechanical Boxes

French, 18th century
Gold, agate, enamel
Gift of the Estate of Ailsa Mellon Bruce, 1970

French craftsmen in the eighteenth century raised goldsmithing and enamelling to a high artistic level. Perhaps the most impressive of the gold boxes in the Bruce Estate gift is one with exquisitely chased and repoussé designs on subjects borrowed from David Teniers (1½ inches high by 3 inches wide). An agate snuff box with a double compartment, designed to be supported on the thumb, is cunningly encased in an elaborate cage of gold (1⅞ inches high by 4 inches wide); and an enamelled mechanical box with a pair of birds which sing while beating their wings and turning on spindles is the very ultimate in piquant fantasy (1⅝ inches high by 3½ inches wide).

Jewel Casket on Stand

French, 18th century
Various woods and bronze doré, 37⅛ inches high by 16¾ inches wide
Gift of the Estate of Ailsa Mellon Bruce, 1970

This is the finest piece of furniture given to the Museum by the Bruce Estate. The quality of the rosewood and kingwood marquetry and the bronze doré mounts is exceptional. Although the casket is stamped "IW," an attribution to the important mid eighteenth-century cabinetmaker "B.V.R.B.," recently identified as Bernard Vanrisamburgh, has been suggested. A small-scale jewelry cabinet *(serre-bijoux)*, once in the Dutasta Collection and very close in type and style to the Museum's casket, bears his initials.

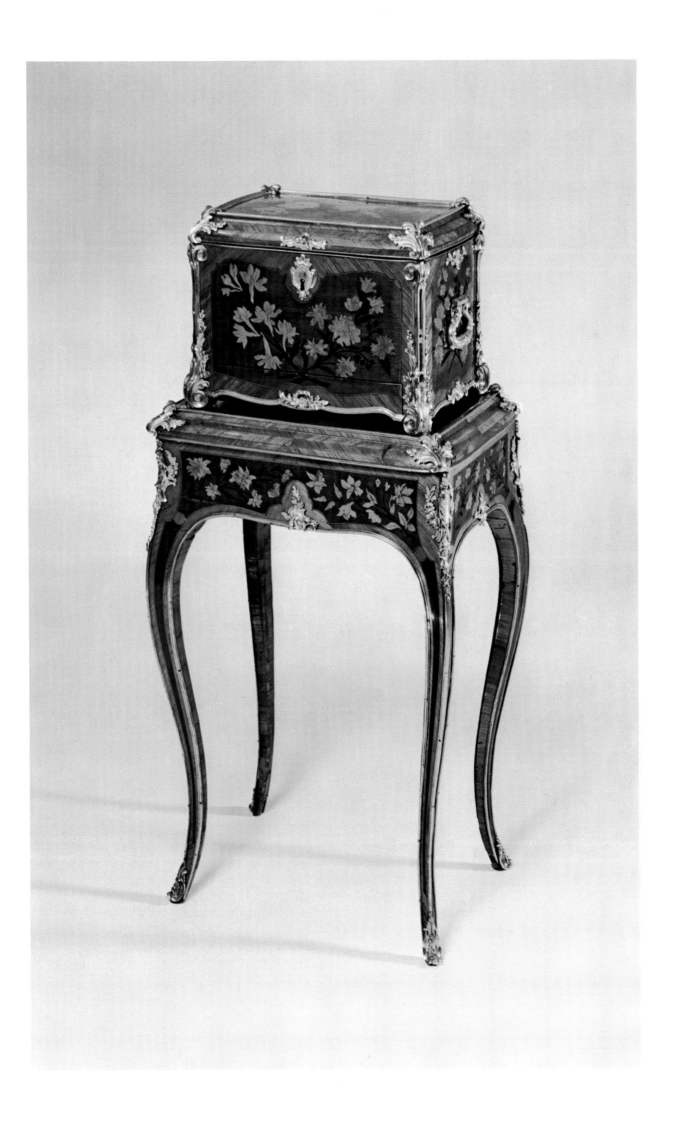

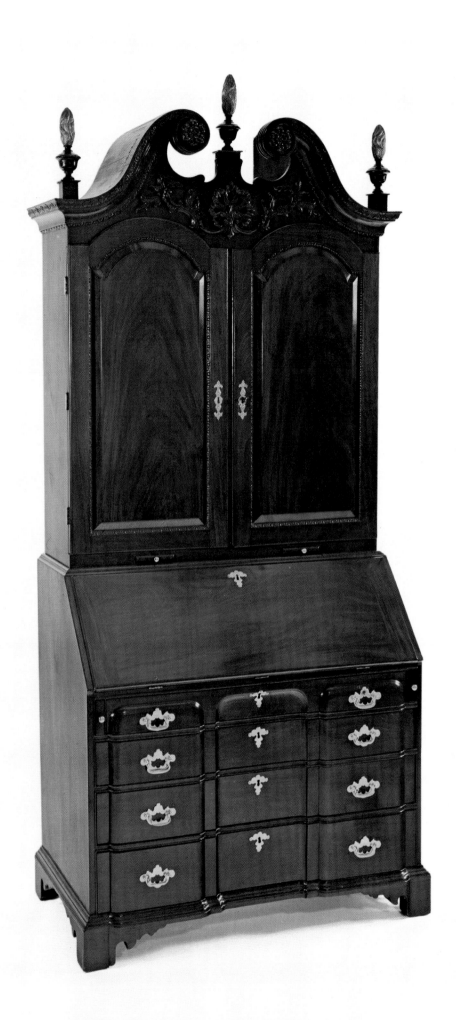

Secretary

American, third quarter of the 18th century
Mahogany, 102 inches high by 43 inches wide
Williams Fund, 1973.

The interior has a shell-covered center door which is flanked by fluted pilasters capped with gilded flames; these echo the three gilded, flame-carved finials of the swan's neck pediment. The carving of the doorjamb moldings and pediment is particularly fine. This magnificent example of American Chippendale furniture may have been made in Philadelphia, despite the fact that the block-front of the lower half would be highly unusual if not unique for that city. The possibility of a New England craftsman working in Philadelphia is not to be excluded.

Fabergé

PETER CARL FABERGÉ, Russian, 1846–1920
Bequest of Lillian Thomas Pratt, 1947

The Museum's Fabergé collection, with over 300 pieces, is one of the largest and most important in the world. One of the five spectacular Imperial presentation Easter eggs in the collection is illustrated here, a rock-crystal globe encircled with a diamond-set band (10 inches high). When the Siberian emerald at the top is depressed, a hook engages and turns the twelve miniatures, which represent palaces associated with the Czarina Alexandra Feodorovna. Czar Nicholas II presented the egg to her in 1896. The pig in lapis lazuli (1½ inches high) illustrates Fabergé's remarkable virtuosity in the carving of minerals, and the buttercup (6 inches high), made by the workmaster Henrik Wigström from translucent yellow agate, gold, nephrite and diamonds, is an incomparable example of ingenuity in the use of disparate materials.

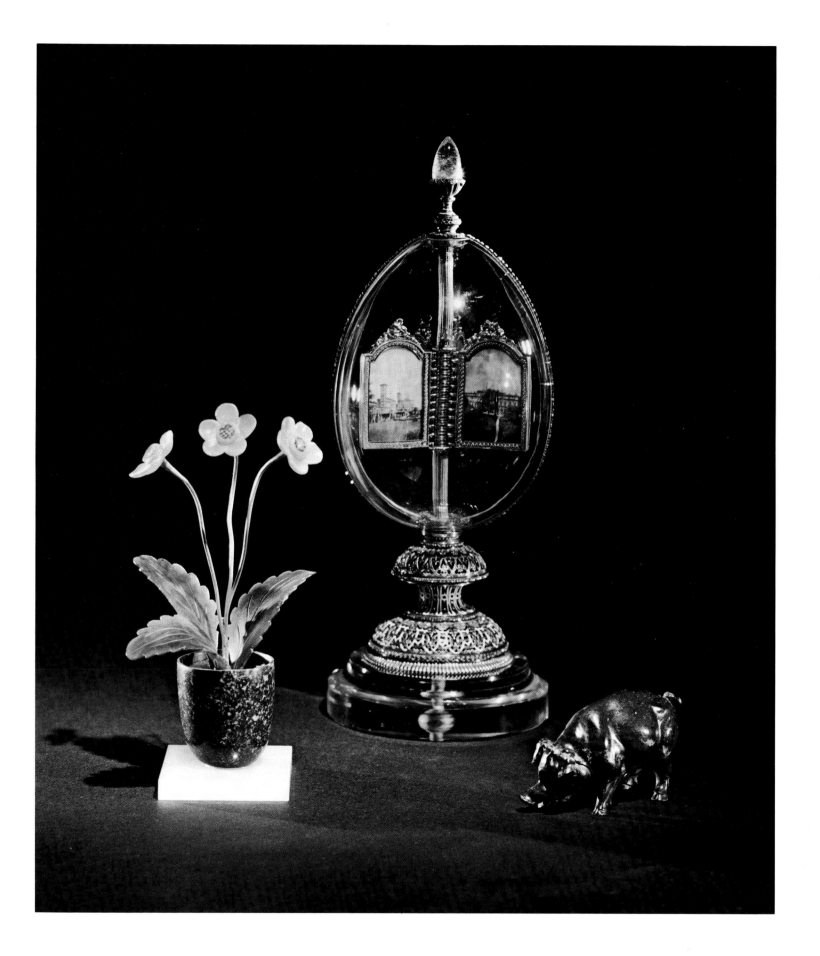

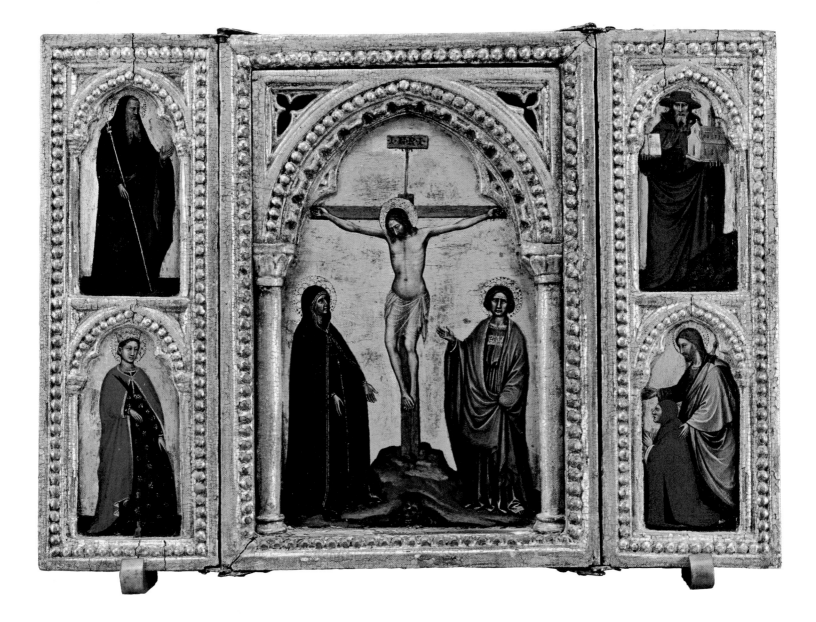

Crucifixion with Saints

ALTICHIERO ALTICHIERI, Italian, circa 1330–1385
Tempera on panel, central panel 12¾ inches high by 8¾ inches wide,
each wing 12¼ inches high by 3¾ inches wide
Glasgow Fund, 1959

Altichiero was Giotto's greatest follower in northern Italy. His style was
formed on Giotto's fresco series in the Arena Chapel in Padua, and
Altichiero himself also painted frescoes in Padua. He later founded the
school of Verona; there he executed important commissions and exerted a
wide influence. The Museum's triptych is a work of great plastic integrity
and dramatic force, and is also the only panel painting that can be attributed
to Altichiero with any certainty.

Assumption of the Virgin

ANDREA DI BARTOLO, Italian, died 1428
Tempera on panel, 80 inches high by 33½ inches wide
Williams Fund, 1954

This large panel is one of the major works by a minor Sienese master of the late fourteenth and early fifteenth centuries. Andrea is first documented in 1389 but is thought to have been active much earlier. Indeed, the Museum's painting, though not dated, is considered to be from the 1370s. It is a splendid example of Sienese painting of this period and has the added interest of an inscription which states that a certain Dominica commissioned the work in memory of her deceased husband, Ser Palamides of Urbino, and her deceased son, Matthew. Husband and son are shown in miniature scale, kneeling at the bottom of the panel.

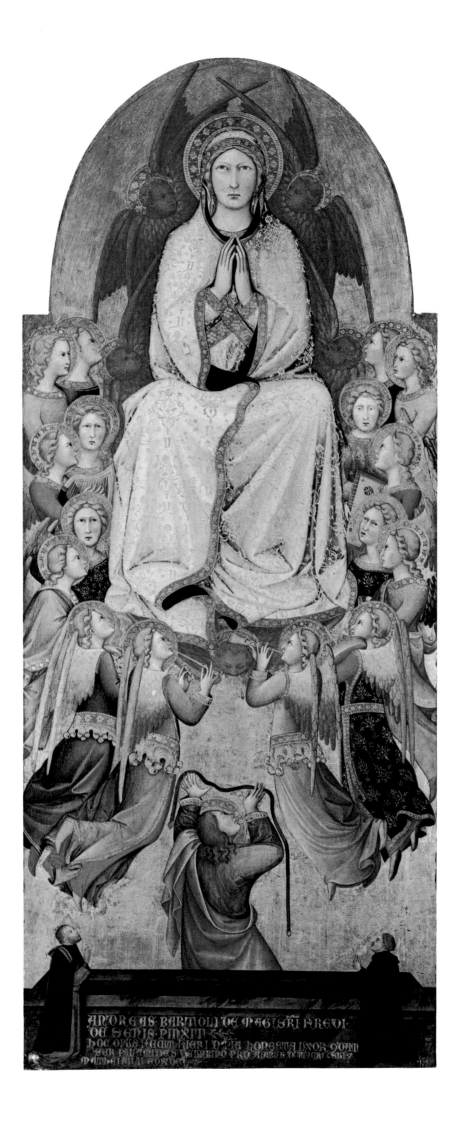

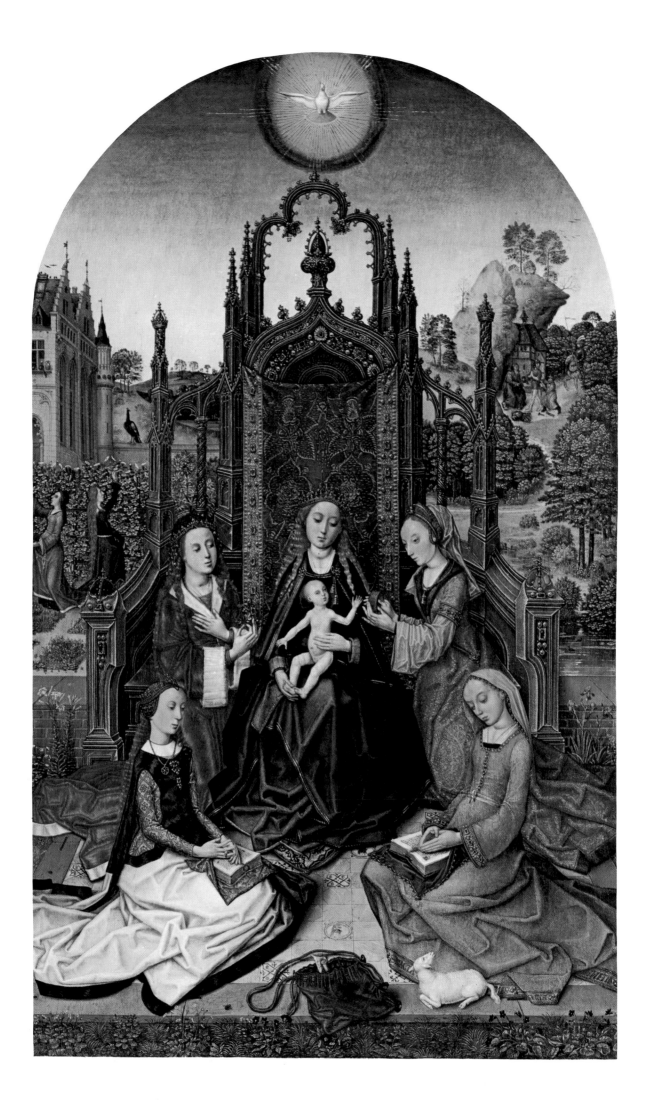

Madonna Enthroned with Saints

Bruges Master of 1499, Flemish, late 15th to early 16th century
Oil on panel, 39⅝ inches high by 23¾ inches wide
Glasgow Fund, 1957

A painting in the Antwerp Museum dated 1499 is the source of the designation of this anonymous artist, who worked in Bruges at the turn of the sixteenth century. The Museum's panel is one of his most polished productions, and conveys the gentle poetry and languorous grace that characterize the painting of Bruges in this period. The composition, which derives from Hugo van der Goes of a generation earlier, was evidently quite popular since it reappears in whole or in part in a number of other works.

The Six Warriors

ALBRECHT DÜRER, German, 1471–1528
Engraving, 5½ inches high by 5¾ inches wide
Council Graphic Arts Fund, 1965

The Six Warriors is a fine impression of an early engraving by Dürer, executed in all probability around 1495, just after his first trip to Italy. There is some evidence of Italian influence in the composition, but a Gothic flavor predominates. This is especially evident in the powerful linear rhythms that transform and practically dematerialize the solid forms of soldiers and landscape, and it is this rhythmic, ornamental quality which is responsible for the sensations of suppressed emotion and nervous tension that pervade the scene.

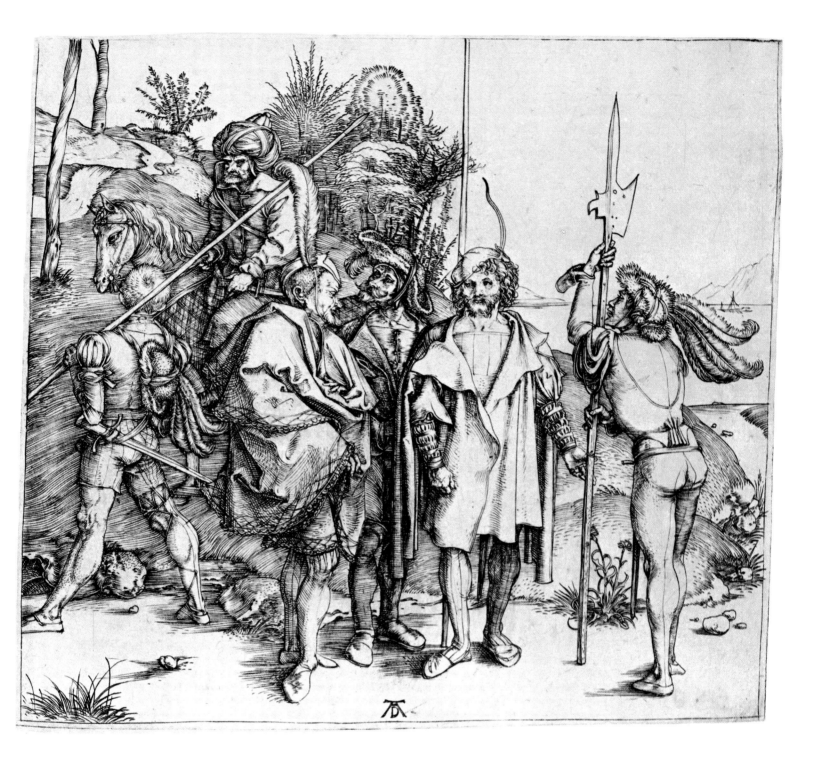

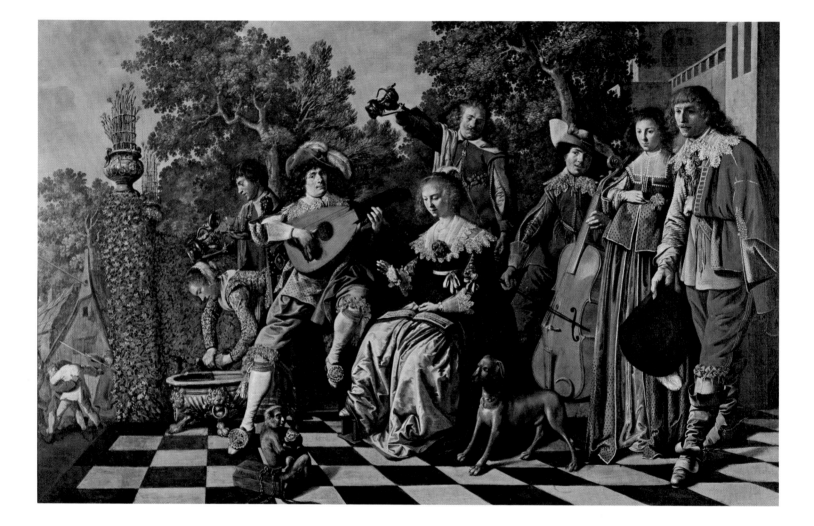

An Allegory of Marital Fidelity

JAN MOLENAER, Dutch, circa 1610–1668
Oil on canvas, dated 1633, 39 inches high by 55½ inches wide
Williams Collection, 1949

A Haarlem artist who also worked in Amsterdam, Jan Molenaer was the husband of Judith Leyster, with whose works his are often confused. He was almost exclusively a painter of genre pictures, although recent scholarship has shown that many of these, instead of being limited to vignettes from everyday life, actually possess allegorical meaning. The Museum painting, for instance, was called *A Musical Party* until the Dutch scholar P. J. J. van Thiel revealed the allegorical theme. With the exception of the couple at the far right, who are the newlyweds, the actions of all the figures, including the animals, have moralistic intent, tending toward either vice (lust, wrath, gluttony) or virtue (temperance, fidelity, moderation).

A River Landscape

SALOMON VAN RUYSDAEL, Dutch, circa 1600–1670
Oil on canvas, dated 1645, 43¼ inches high by 61¼ inches wide
Williams Fund, 1973

Salomon van Ruysdael began painting river views in 1631, and in these early works he employed many of the same conventions as his contemporary Jan van Goyen. The Museum's *River Landscape* is one of the artist's masterpieces of the 1640s and shows how much his work had gained in freedom and spatial breadth. Although the composition is based on a pronounced diagonal movement from the right foreground to the left distance, the picture achieves its spatial expression primarily from tonal unification and a luminosity of a remarkably diaphanous quality.

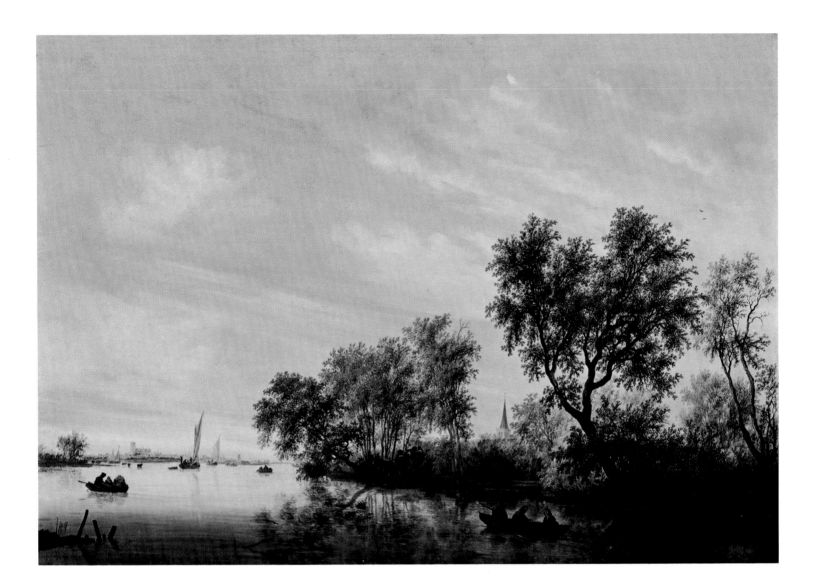

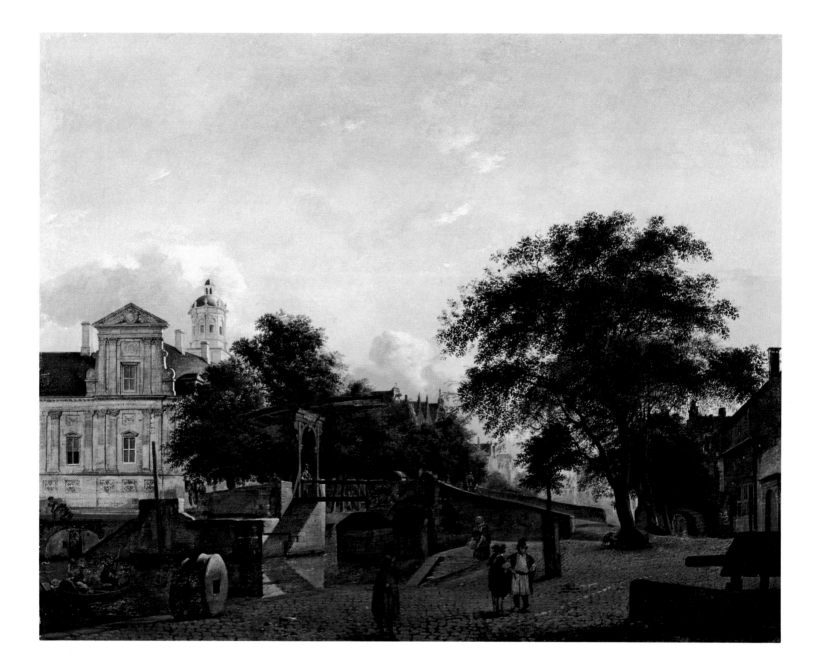

View in Amsterdam

JAN VAN DER HEYDEN, Dutch, 1637–1712
Oil on panel, 17⅝ inches high by 21¾ inches wide
Williams Fund, 1964

Van der Heyden's views of Amsterdam, confined to the decade 1660–70, are, surprisingly, the first ones known to have been done in the seventeenth century. The paintings are infinitely meticulous in the rendering of detail, although always underlying this sharp focus is a strong feeling for structure and organization. In realizing his pictorial goals, the artist frequently took liberties with topography: in this painting the dome of the Amsterdam Town Hall is shown accurately, but its relation to the canal and other buildings derives entirely from the artist's imagination.

Pallas and Arachne

PETER PAUL RUBENS, Flemish, 1577–1640
Oil on panel, 10½ inches high by 15 inches wide
Williams Fund, 1958

The most important commission of Rubens' last decade was the series of
mythological paintings ordered in 1636 by Philip IV for his hunting lodge,
the Torre de la Parada. Most of the finished paintings were destroyed by fire
in 1710, but more than fifty autograph oil sketches exist which preserve
Rubens' original conception in all its freshness, and which in their execution
are the supreme expression of the artist's late manner. The Museum's
sketch, like most of the others, treats a subject from Ovid's *Metamorphoses*:
in this case, Pallas Athena's chastisement of the weaver Arachne, who is
about to be transformed into a spider.

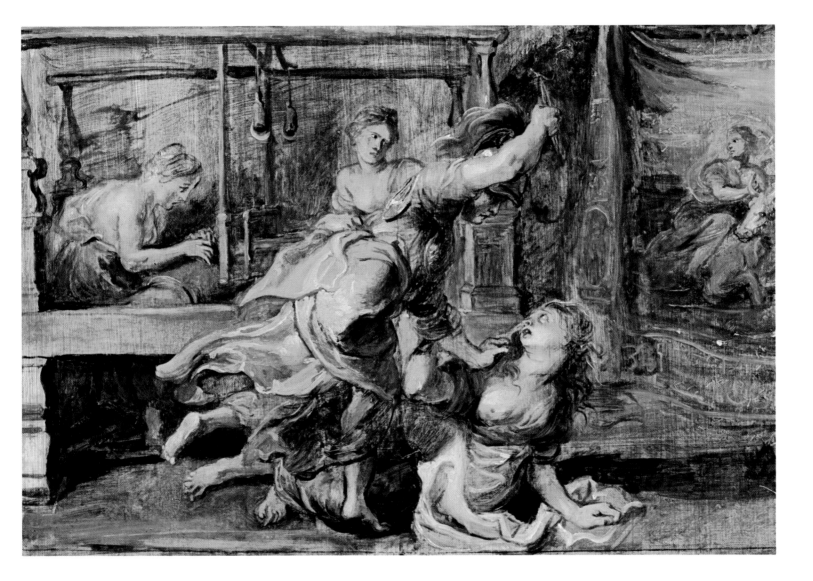

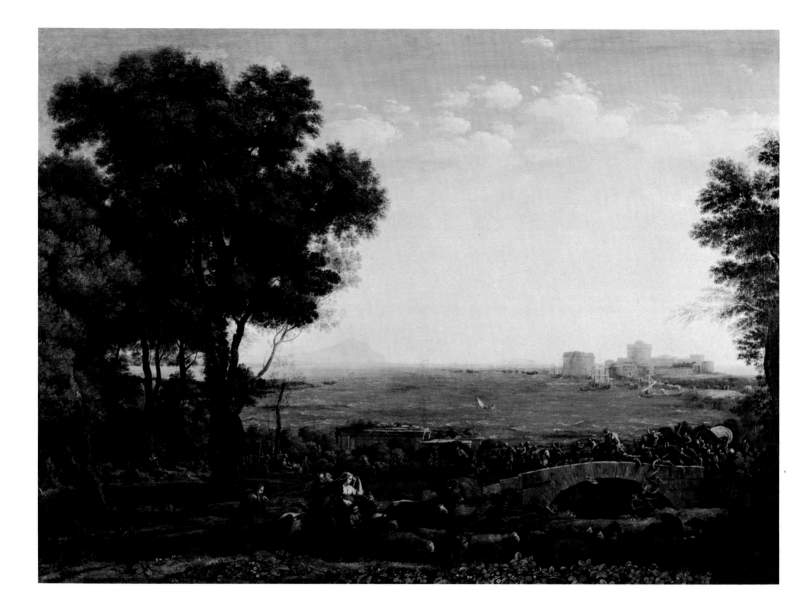

Battle on a Bridge

CLAUDE LORRAIN, French, 1600–1682
Oil on canvas, 41 inches high by 55 inches wide
Williams Fund, 1960

This painting possibly represents the battle on the Milvian Bridge between Constantine and Maxentius. It may also refer to some lesser encounter, not identified, or may simply be intended as fantasy. Two things are certain, however: first, the painting was conceived as a pendant to a *Rape of Europa* now in the Royal Collection at Buckingham Palace and, second, it shares with the latter that grandiose spatial design and overwhelming sense of pathos which are the hallmarks of Claude's style.

The Death of Regulus

SALVATOR ROSA, Italian, 1615–1673
Oil on canvas, 60 inches high by 86½ inches wide
Williams Fund, 1959

Captured by the Carthaginians, the Roman Consul Marcus Atilius Regulus
was sent to Rome to sue for peace; but instead he urged the Senate to
decline the unfavorable Carthaginian terms. He honored his oath to return
to Carthage, and suffered a ghastly death encased in a spike-studded barrel,
a paradigm of stoic virtue. Salvator Rosa is best known for his landscapes
and scenes of bandits and battles, yet his highest ambition was to be recog-
nized as a painter of historical subjects. *Death of Regulus* is his masterpiece in
this genre, and in terms of dramatic coherence and the convincing expres-
sion of grim and tragic mood it is unsurpassed in his work as a whole.

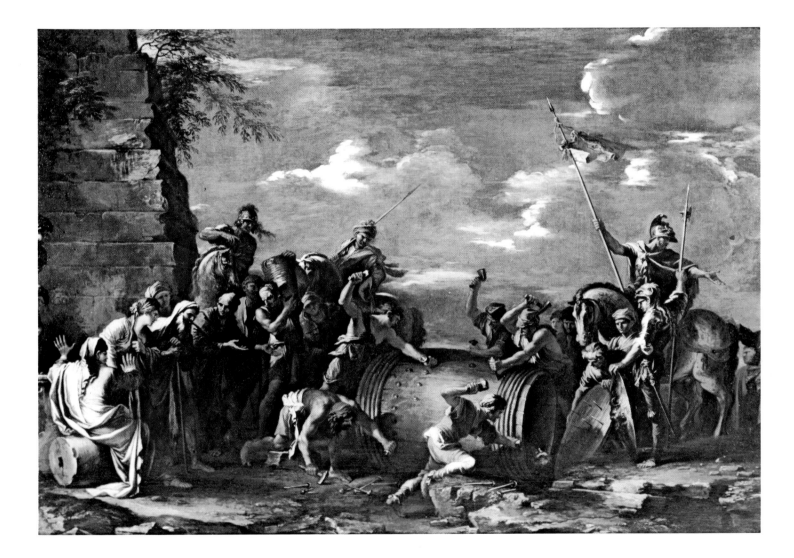

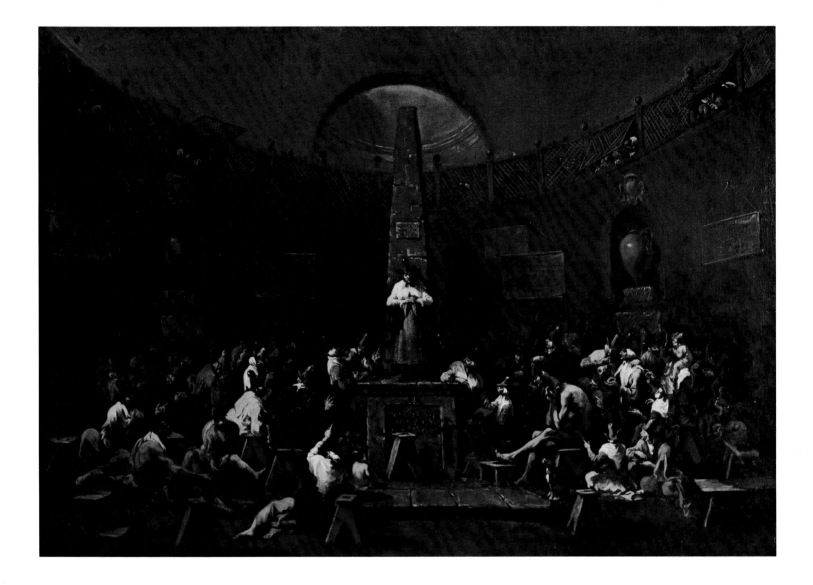

The Quaker Meeting

ALESSANDRO MAGNASCO, Italian, 1677–1749
Oil on canvas, 38 inches high by 53⅝ inches wide
Williams Fund, 1960

Wild, stormy landscapes, usually occupied by monks, are the most common
themes of Magnasco's paintings, and his style, with its flashy brushwork
and flickering light, is perfectly suited to his subject. His interior scenes are
painted in the same manner, though they are more varied in subject. The
Museum's picture is traditionally called *Quaker Meeting,* although *Gypsy
Tribunal* is an equally valid title. Whatever the nature of the event, the
atmosphere of mystery, bizarre disharmony, and anguish is characteristic of
the kind of expressionism that Magnasco invented.

Le Lorgneur

ANTOINE WATTEAU, French, 1684–1721
Oil on panel, 12¾ inches high by 9⁷⁄₁₆ inches wide
Williams Collection, 1955

The *lorgneur,* or ogler, garbed in slashed satin, plays his guitar with a nonchalant but wistful detachment that sets a mood typical of the *fête galante.* Watteau invented this class of painting, a category which was officially recognized by the Académie Royal in 1717 when he submitted his celebrated *Pilgrimage to Cythera.* The Museum's *Le Lorgneur* is the best of numerous versions; in the eighteenth century it was both engraved and used as a model for a vase from the Buen Retiro porcelain factory.

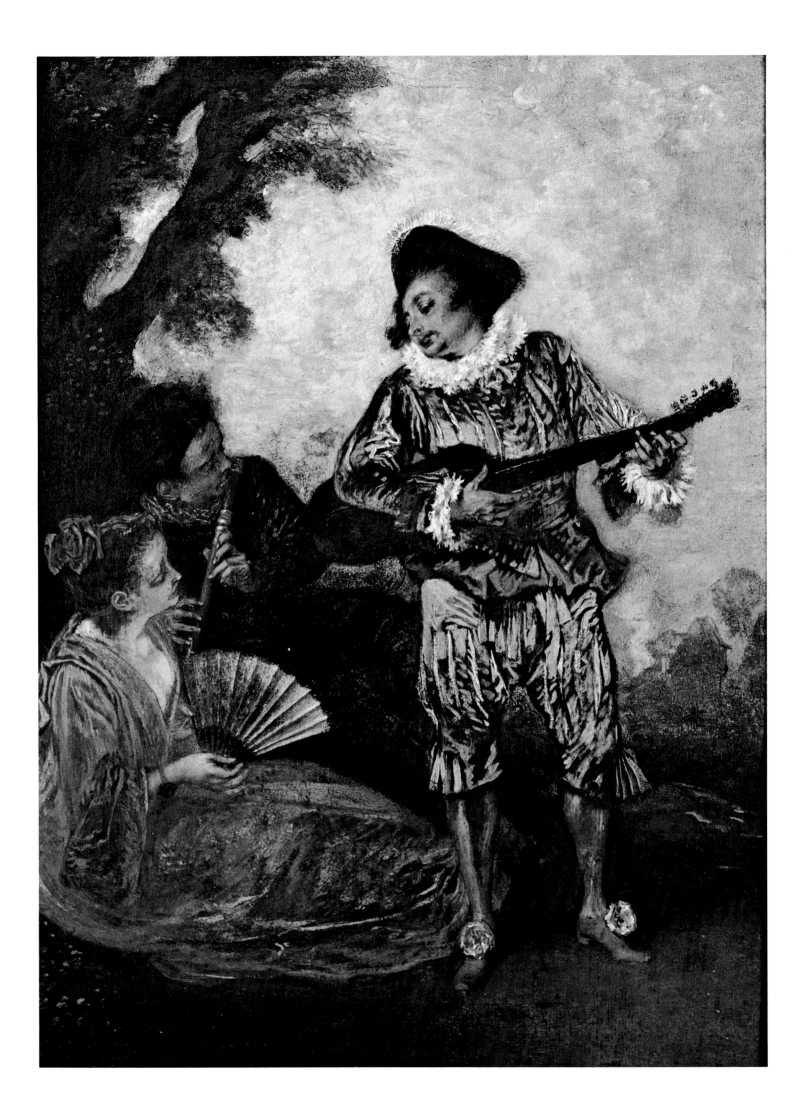

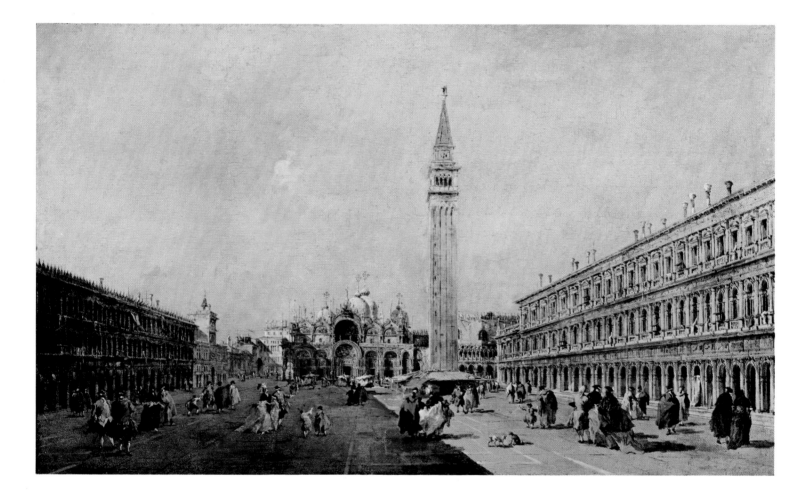

Piazza San Marco

FRANCESCO GUARDI, Italian, 1712–1793
Oil on canvas, 18⅝ inches high by 30⅝ inches wide
Williams Fund, 1953

In the eighteenth century the more linear and precise paintings of Canaletto were preferred to Guardi's. Today, with the experience of French Impressionism behind us, it is the crisp handling and broad atmospheric effects of Guardi that appeal. This is one of his best views of the Piazza, dating from late in the artist's life, possibly as late as 1785.

The Finding of the Laocoön

HUBERT ROBERT, French, 1733–1808
Oil on canvas, dated 1773, 47 inches high by 64 inches wide
Glasgow Fund, 1962

This is a painting in Robert's most romantic and at the same time heroic vein. The rediscovery in 1506 of the *Laocoön,* the celebrated Hellenistic sculpture, was one of the great events of the Renaissance, and its fame continued undiminished into the eighteenth century. Lessing's *Laokoön* was published seven years before Robert's painting, and Diderot devoted eloquent pages to the sculpture. Robert's setting is a vast basilica which is not without striking similarities to the Grande Galerie of the Louvre.

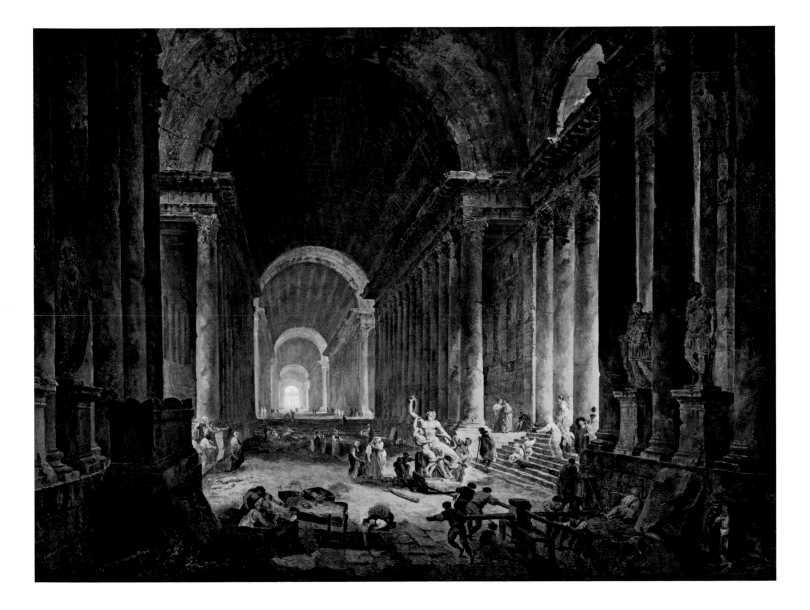

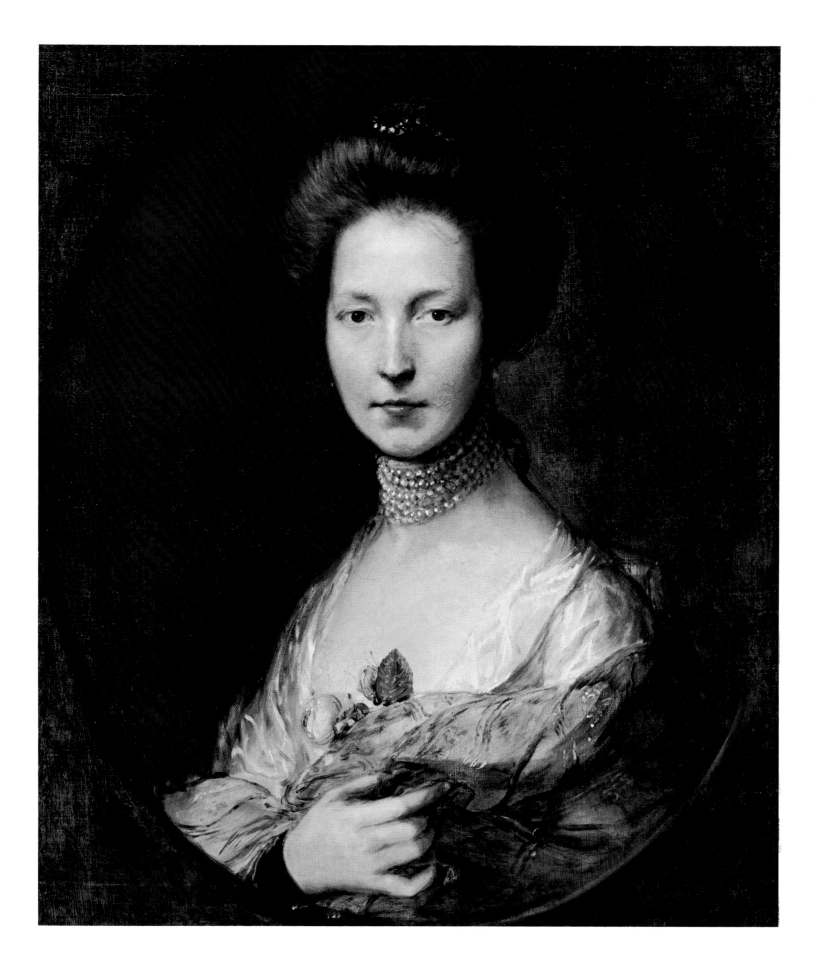

Miss Clarges

THOMAS GAINSBOROUGH, English, 1727–1788
Oil on canvas, 30 inches high by 25 inches wide
Williams Collection, 1949

Gainsborough moved from Bath to London in 1774. This portrait of Miss
Mary Clarges (later to become Mrs. George Narbone Vincent) was painted
after his move but prior to 1780. It possesses in full degree the looseness
of handling, spontaneity, and brio of his mature style. These are the
qualities which distinguish Gainsborough's work so markedly from that of
his archrival, Reynolds, and which Reynolds himself singled out in render-
ing posthumous homage to Gainsborough in his fourteenth *Discourse.*

View on the Seine

RICHARD PARKES BONINGTON, English, 1802–1828
Oil on mill-board, 12 inches high by 15¾ inches wide
Gift of Mrs. Lincoln Davis in Memory of her Son, George Cole Scott,
on Behalf of the Family, 1962

A prodigy who died at twenty-five, the same age as his contemporary Keats,
Bonington was an artist of extraordinary facility. He was trained in France
and spent much of his short career there. The *View on the Seine* was probably
painted in 1825, the year in which Bonington initiated a warm friendship
with Delacroix, whom he significantly influenced. Delacroix might well
have had the Museum's picture in mind when he wrote enthusiastically of
Bonington's "lightness of execution," the "diamond-like" quality of his
work, and its capacity for "charming and seducing the eye."

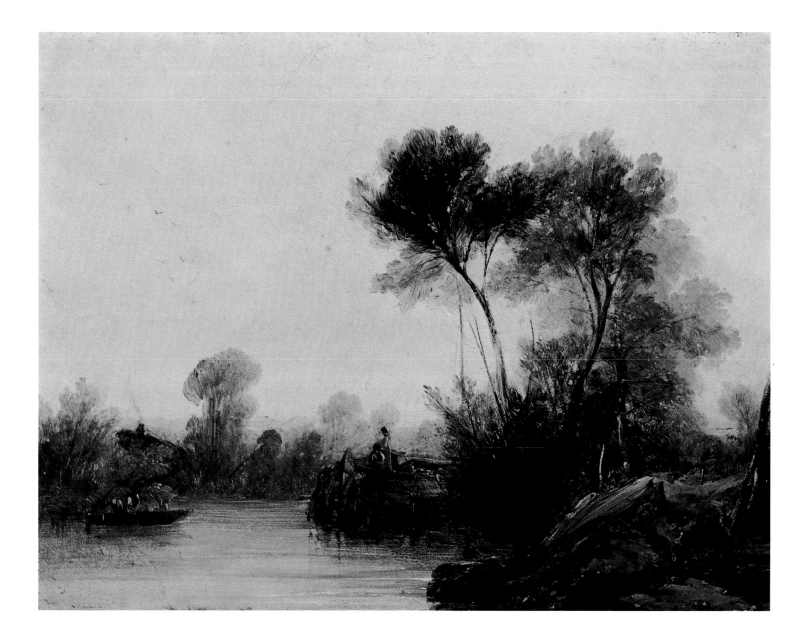

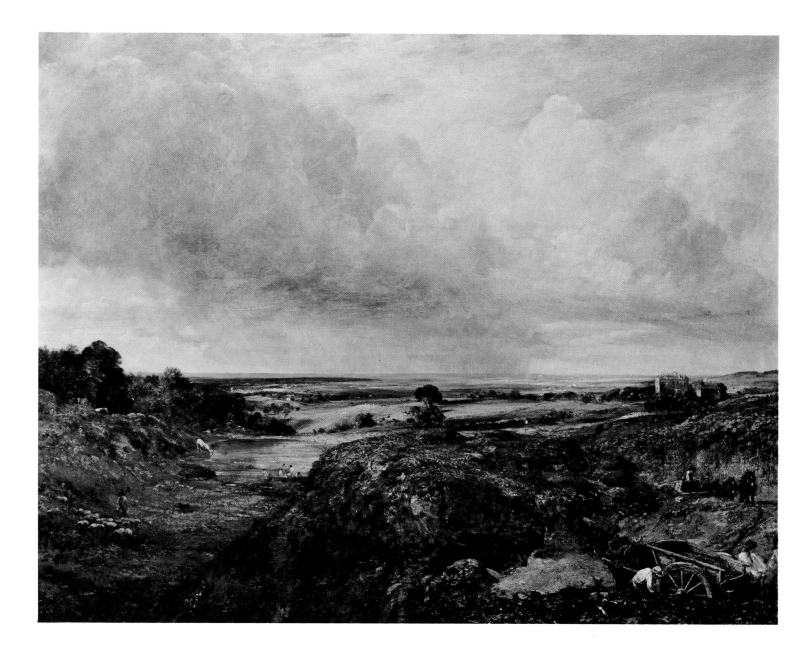

Hampstead Heath

JOHN CONSTABLE, English, 1776–1837
Oil on canvas, 24½ inches high by 30¾ inches wide
Williams Collection, 1949

Beginning in 1819 Constable rented a house in Hampstead; from that time onward appear his celebrated studies of cloud and sky effects. He also painted complete landscapes of the Heath, and the Museum's painting represents one of his favorite views. It was exhibited in the Royal Academy in 1825, a year after it was painted. Here we see Constable, "the natural painter," at his best with a vast, luminous, stormy sky blending dramatically with sandpit, meadow, and dale.

Portrait of General Nicholas Guye

FRANCISCO GOYA, Spanish, 1746-1828
Oil on canvas, 41¾ inches high by 33⅜ inches wide
Anonymous Gift, 1971

General Guye was a prominent soldier in the French occupation forces in Spain. In March 1810 he was appointed Governor of Seville, and it was sometime during the succeeding months that he was painted by Goya. It is a curious fact that Goya, who was a patriot and no friend of the French, used this occasion to create one of his most powerful portraits. Dressed in full uniform with the badges of the Legion of Honor and the Royal Order of Spain on his braid-encrusted breast, General Guye is enveloped in an aura of unequivocal command. It is an almost iconic presence, but behind the aloofness and beneath the scintillating, painterly surface the complexities and depths of personality resonantly emerge.

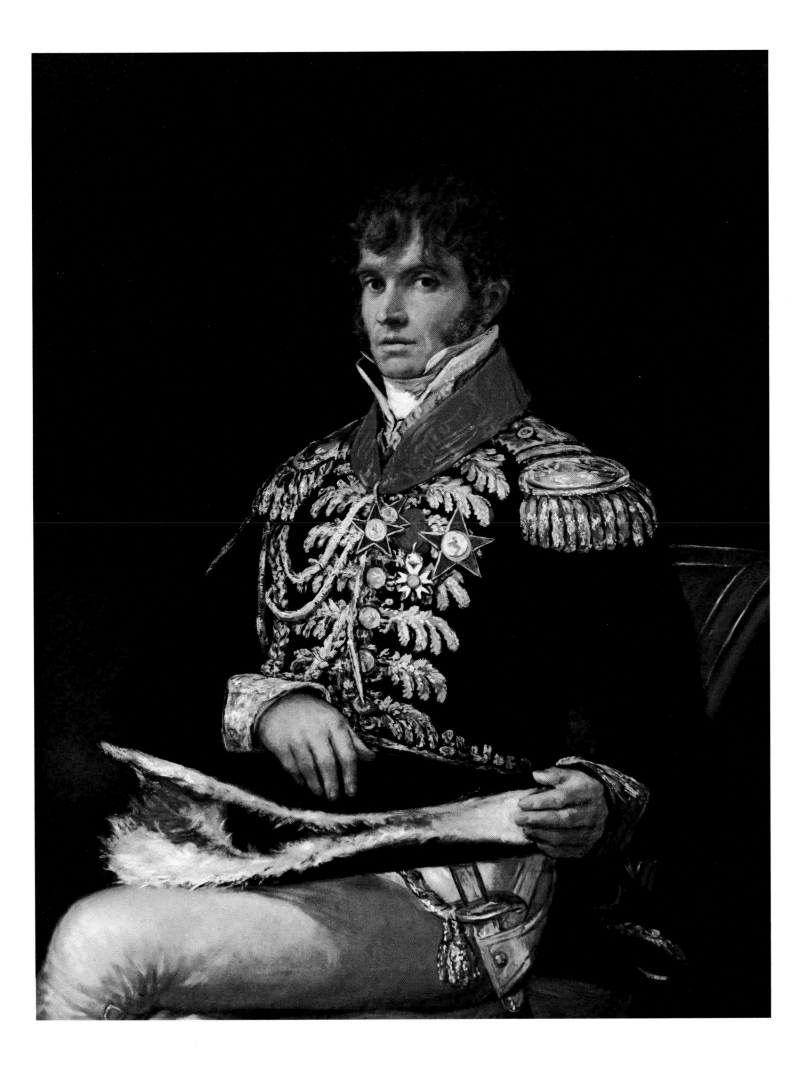

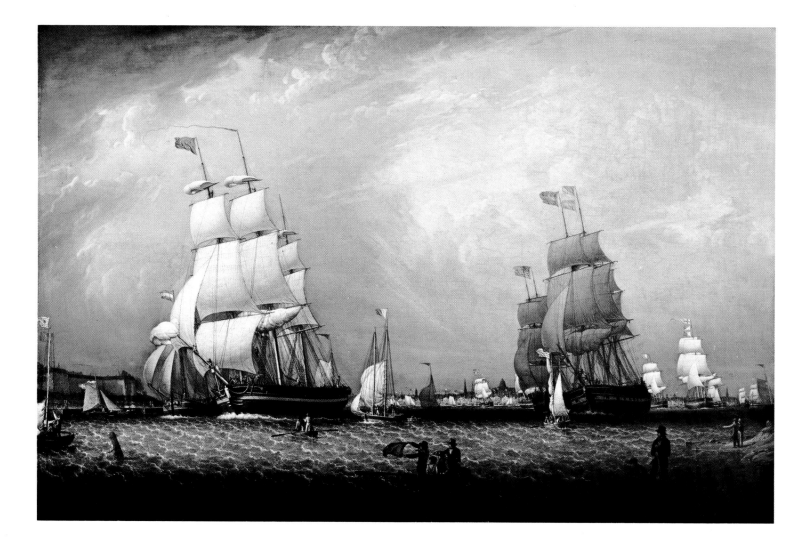

Boston Harbor from Castle Island

ROBERT SALMON, English-American, born 1775, died circa 1845
Oil on canvas, dated 1839, 40 inches high by 60 inches wide
Williams Fund, 1972

Robert Salmon came to America in 1828. Over fifty years old at the time, he had a successful and prolific career behind him as a marine painter in England. The paintings of harbors in Boston and elsewhere on the New England coast which he executed during his remaining years were of signal importance in the development of a native school of American marine painting. *Boston Harbor from Castle Island,* one of his most ambitious and successful works, depicts the ship *Charlotte* leaving Boston Harbor in a brisk wind. As the Salmon scholar John Wilmerding has written, "...it balances busy anecdotal detail and spaciousness of effect, documentation and imaginative design, forms in light and in shadow, sensations of motion and of stopped action, a feeling at once of intimacy and of monumentality" (*Arts in Virginia,* Volume 14, Number 2).

Amadis de Gaule

EUGÈNE DELACROIX, French, 1798–1864
Oil on canvas, dated 1860, 21½ inches high by 25¾ inches wide
Williams Fund, 1957

Amadis de Gaule was a medieval romance, possibly of Provençal origin, which appeared in Portuguese and French in the late sixteenth century. It underwent several later French editions, the latest in 1859, a year before Delacroix's painting. In the incident depicted, the hero, Amadis, delivers a maiden from the villain Galpan's castle. It is a late work, intimate in scale but passionate in conception, and painted with a jewel-like richness of color.

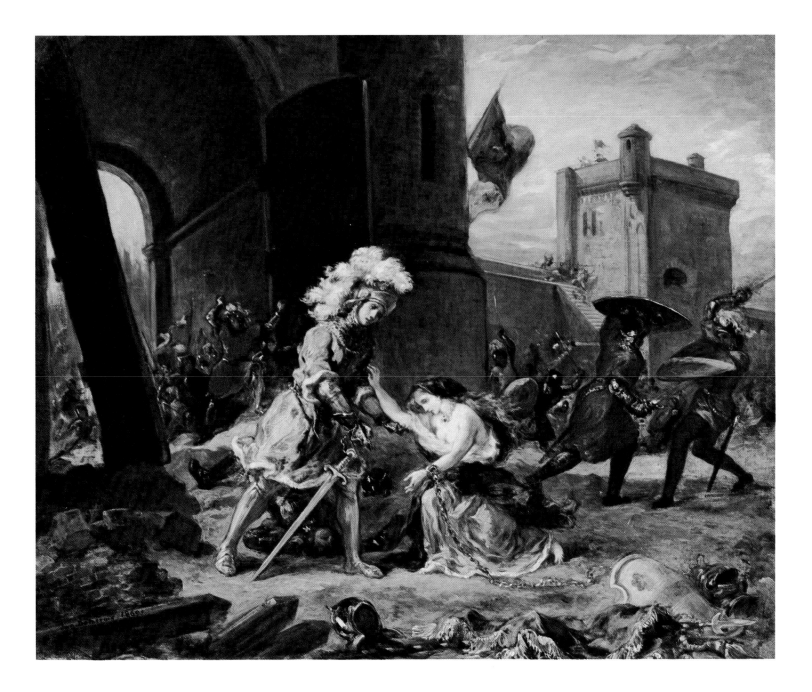

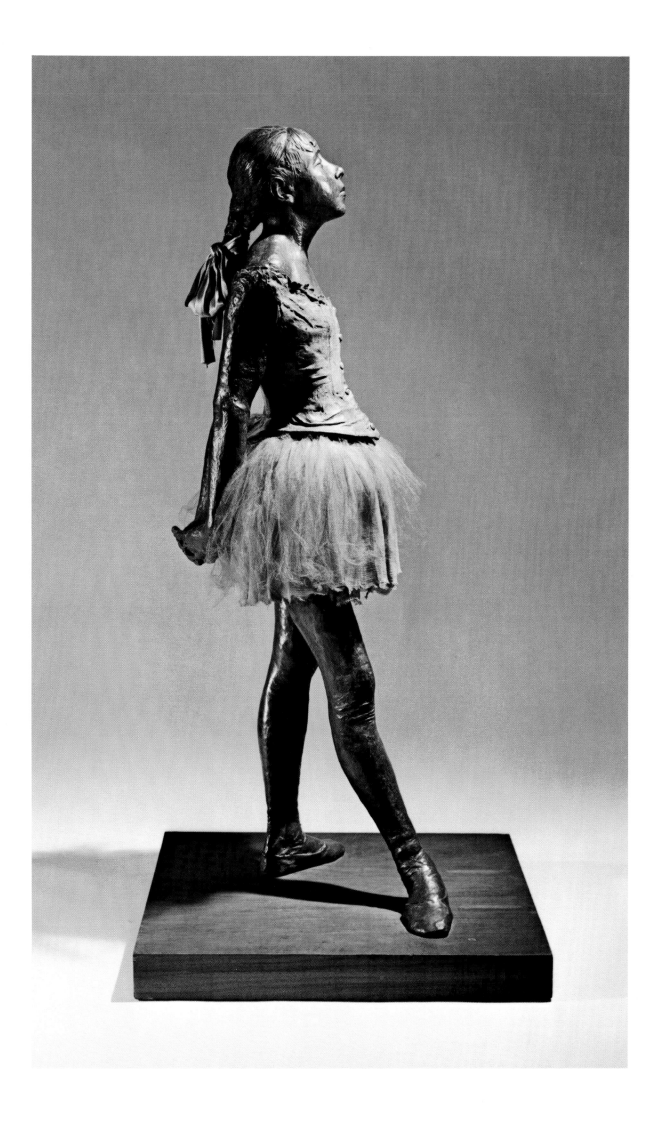

Ballet Dancer, Dressed

EDGAR DEGAS, French, 1834–1917
Bronze, 38½ inches high
Museum Purchase, 1945

Degas worked in sculpture intermittently throughout his life, although none of his wax and clay models were cast before his death and only one, *Ballet Dancer, Dressed,* was ever exhibited publicly. In this sculpture, his most ambitious work, the artist incisively captures the impish, piquantly blasé air of the young dancer, who is shown standing in a careless, inelegant pose. This desire for expressiveness at the expense of conventional grace, coupled with a thoroughly plastic coherence, embodies Degas' distinctive contribution to the art of his time.

Jeunes Filles Regardant un Album

AUGUSTE RENOIR, French, 1841–1919
Oil on canvas, 32 inches high by 25½ inches wide
Williams Fund, 1953

In the 1880s Renoir reacted against the Impressionism of the preceding decade. His interest shifted from the ephemeral chromatic effects produced by strong illumination to figural composition, line, and decorative pattern. The Museum's painting dates from the 1890s and is a product of the further evolution of this tendency: the composition is monumental, the figures themselves have taken on a new fullness and soft plasticity, and his color shows a marked transparency and mellowness.

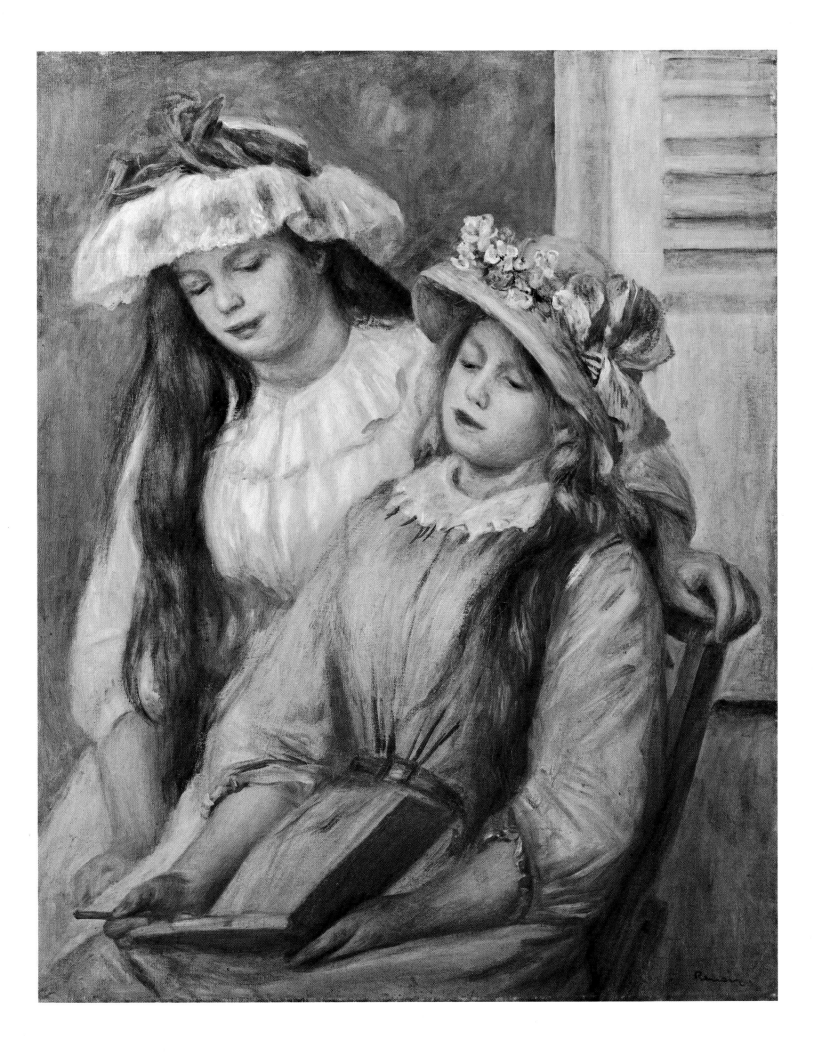

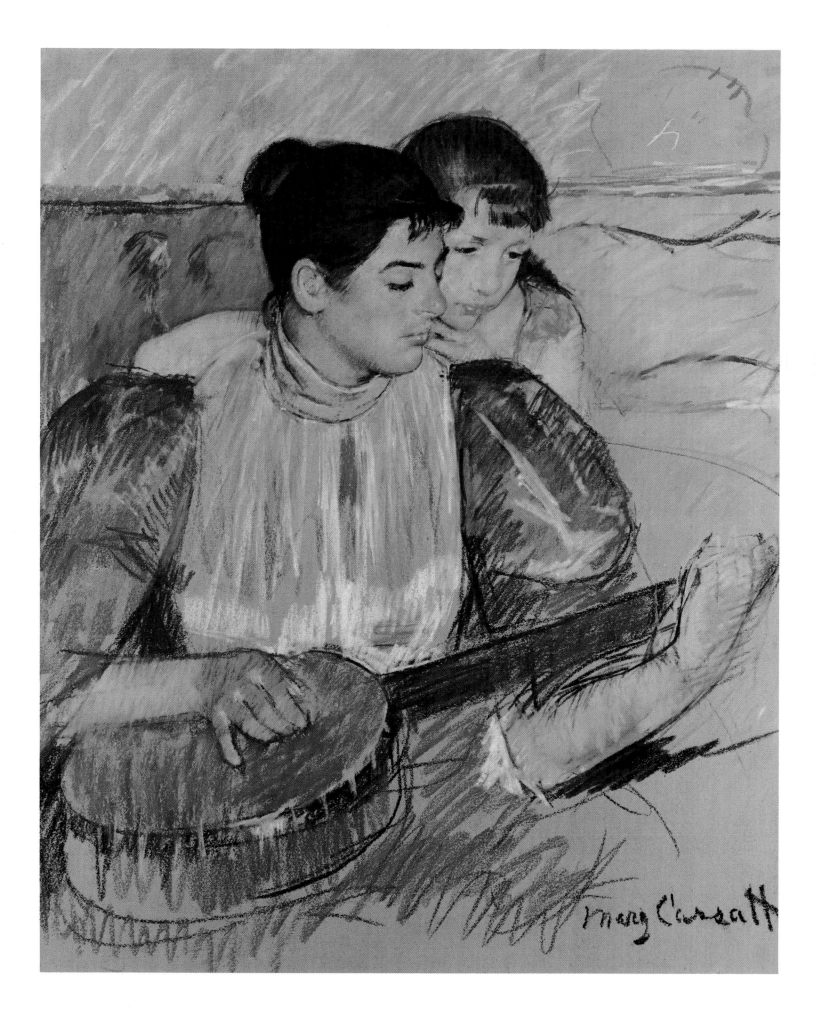

The Banjo Lesson

MARY CASSATT, American, 1845–1926
Pastel on paper, 28 inches high by 22½ inches wide
Williams Fund, 1958

Mary Cassatt was strongest when working with pastels, which is not surprising when one realizes that the same, with some qualification, might also be said of her mentor, Degas. *The Banjo Lesson* is a splendid demonstration of her skill in the medium and is unsurpassed in the elegance of its pictorial handling. It is dated 1894 on the basis of a print of that date with the same composition, and is related to a smaller pastel, showing only the upper parts of the figures, in Boston's Museum of Fine Arts.

Becquet

JAMES McNEILL WHISTLER, American, 1834–1903
Etching and drypoint, 10½ inches high by 7½ inches wide
Collectors' Circle Fund, 1973

This is a portrait of Just Becquet (1829–1907), a sculptor, amateur cellist and friend of Whistler from his bohemian Paris days in the 1850s. The print was included in Whistler's *Thames Set*, which was published in 1871 but executed some ten or more years earlier. The Museum's impression is one of only five known of the first state—a brilliant impression that preserves the rich burr of the drypoint and the warm, wash-like tone of the hand-wiped plate.

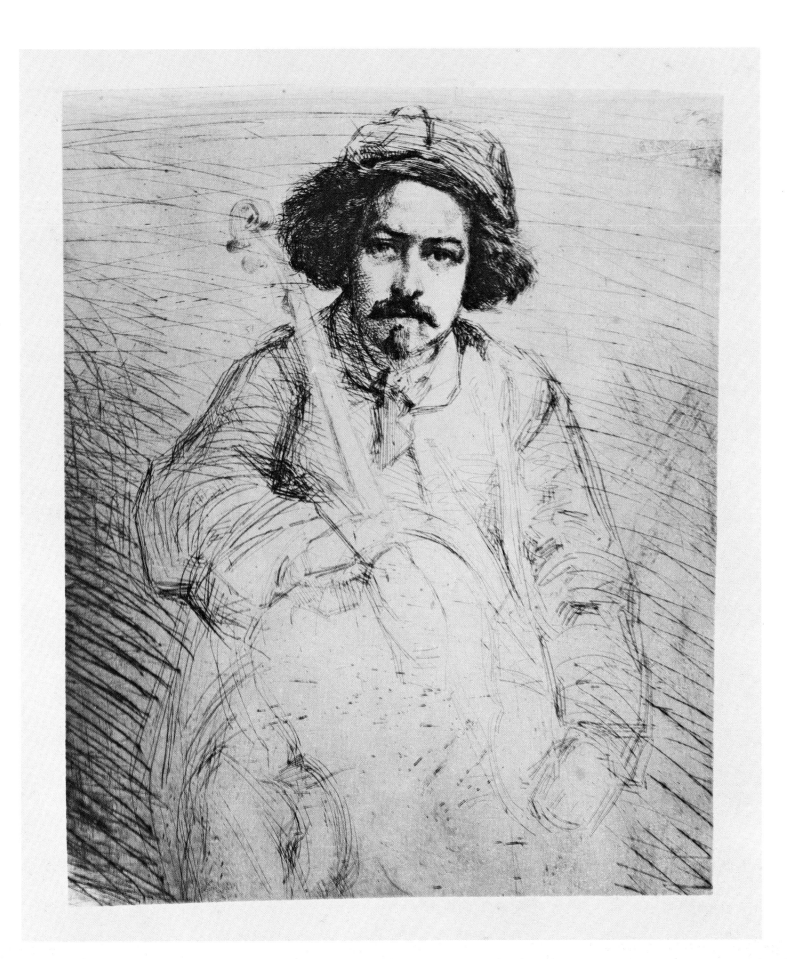

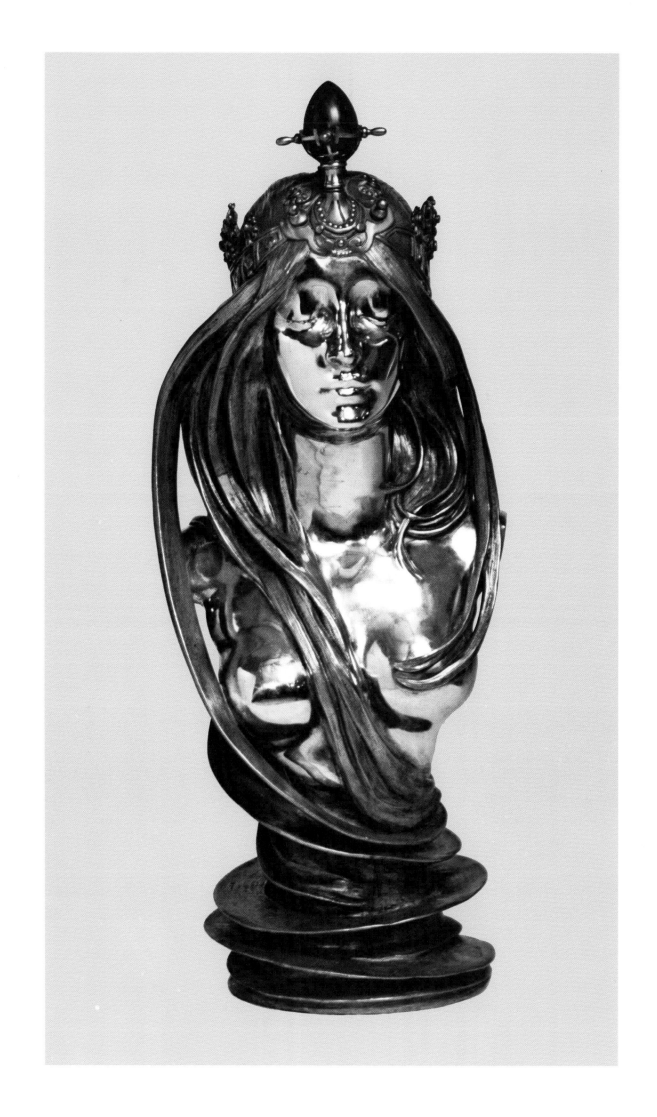

Art Nouveau Bust

ALPHONSE MUCHA, Czechoslovakian, 1860-1939
Bronze, 27½ inches high
Frances and Sydney Lewis Art Nouveau Fund, 1972

As painter, sculptor, jewelry designer and, above all, maker of posters, Mucha was probably the most influential figure in the Art Nouveau movement. His sculpture is the least known part of his production, and of the few bronzes that have reappeared in recent years the Museum's female bust is the most remarkable. The enigmatic, sultry beauty of the unknown subject is typical of what has been aptly called the "hothouse" variety of Art Nouveau, and equally so are the highly ornamental gilded and silvered surface and the cascades of swirling drapery and tresses.

The River

ARISTIDE MAILLOL, French, 1861–1944
Lead, 48¼ inches high by 90½ inches long
Williams Fund, 1970

One of the most important of Maillol's late works, *The River* exists in eight casts, the Museum's being number two. The evolution of the sculpture is complicated, since the plaster model was composed from pieces destined for another work, *The Mountain*. The sculptor originally conceived the work as a monument to the writer and anti-war propagandist Henri Barbusse, and may have planned to have the figure's flank pierced by a sword. In being unprogrammatic, however, the statue is no less dynamic, and exists as a heroic expression of primal plastic forces.

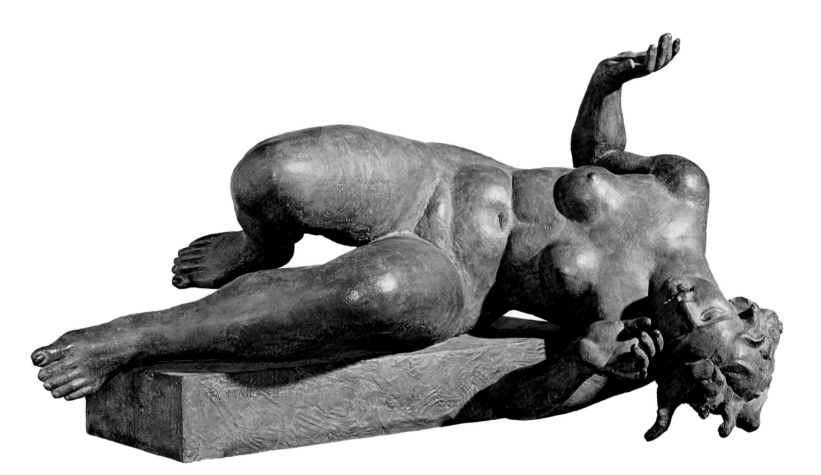

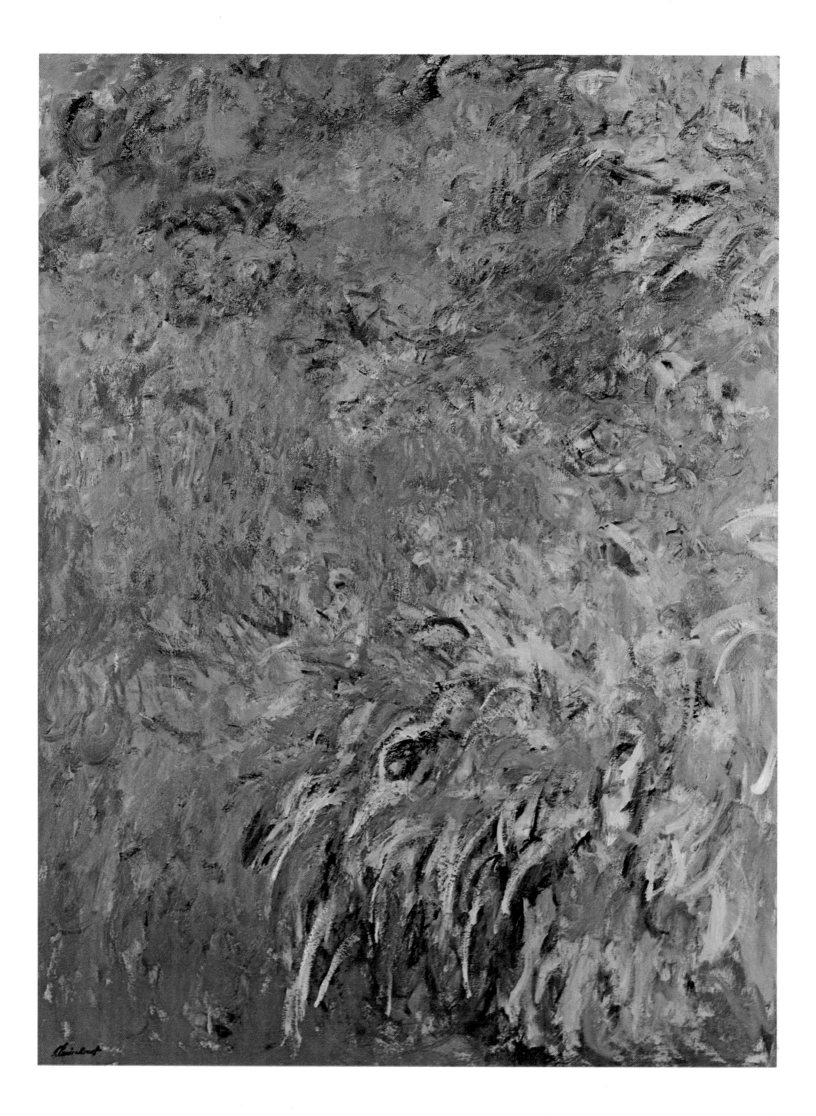

Irises by the Pond

CLAUDE MONET, French, 1841–1926
Oil on canvas, 78½ inches high by 59¼ inches wide
Williams Fund, 1971

The last forty-three years of Monet's life were spent at Giverny, where from 1891 on he developed an elaborate water garden, diverting a nearby stream to create a pool filled with water lilies and other aquatic plants. This garden became the constant subject of the artist's work, especially toward the end of his life, and *Irises by the Pond* is a magnificent example of the very latest of these paintings. In them, Monet virtually immerses himself in the material substance of his subject and creates a pictorial transformation of visionary intensity.

Woman with Kerchief

PABLO PICASSO, Spanish, 1889–1973
Watercolor, gouache and charcoal, 25 inches high by 19½ inches wide
Gift of T. Catesby Jones, 1947

Woman with Kerchief was painted in the summer of 1906 in Gosol, a town in the Andorra valley of the Spanish Pyrenees. Picasso's work at Gosol falls within the so-called Rose, or early Classic, phase of his development. In mid-1905, the Blue Period—with its melancholic mood, emaciated figures and blue tonality—yields to a style in which pinks, tans and, at Gosol, a deeper terra-cotta tone predominate. Even more significant, the human form is treated with a greater breadth and amplitude, and the introspective disquietude of the Blue Period is replaced by a kind of classical serenity. Few works illustrate this dramatic change better than *Woman with Kerchief.*

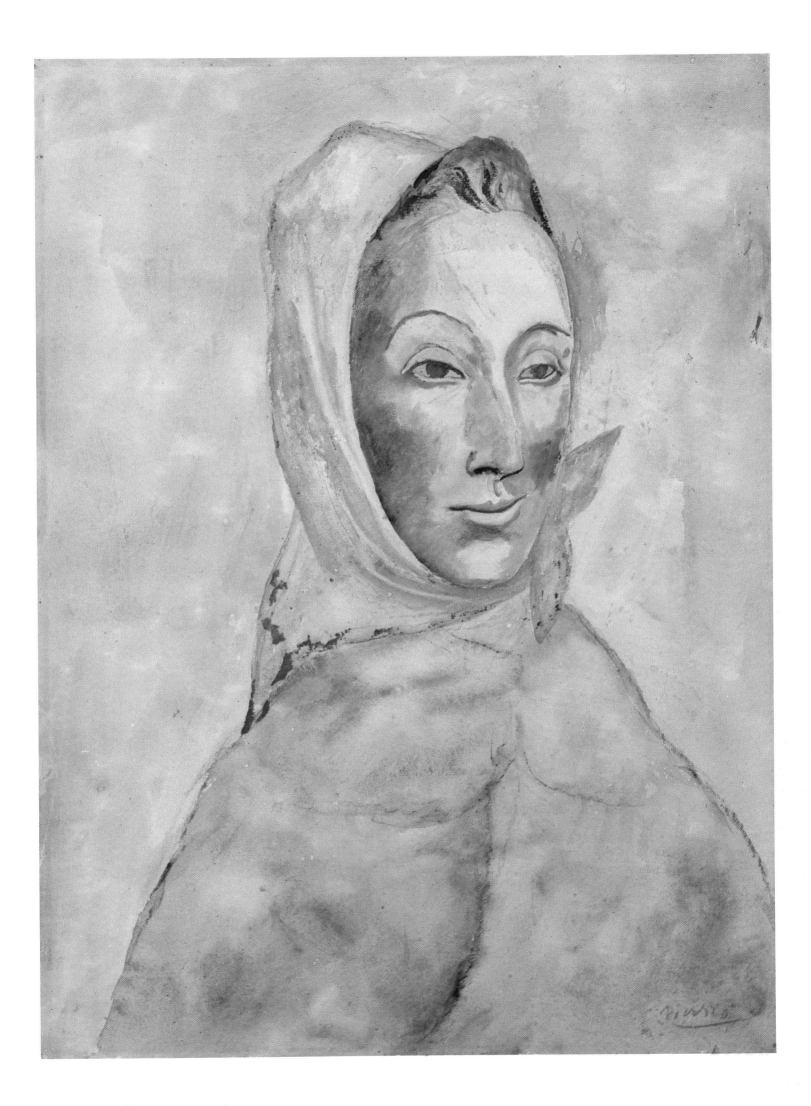

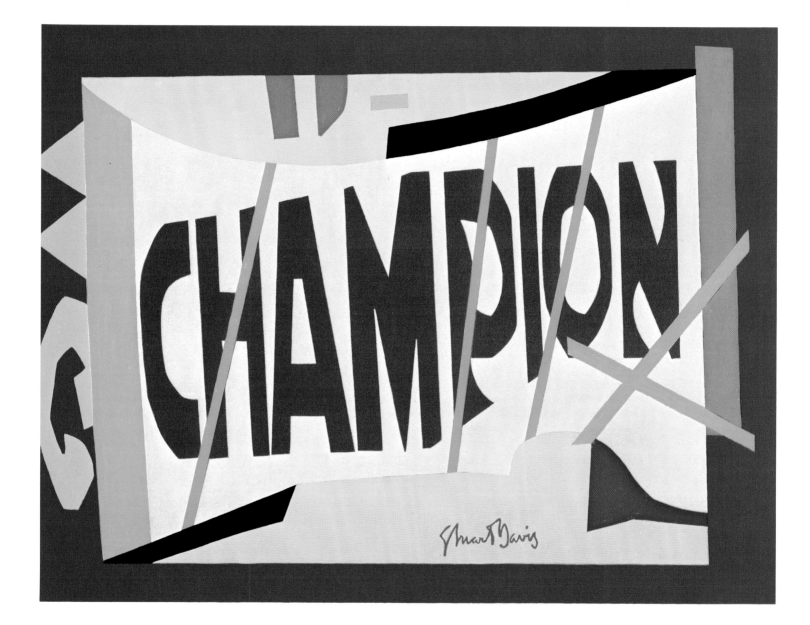

Little Giant Still Life

STUART DAVIS, American, 1894–1964
Oil on canvas, 33 inches high by 43 inches wide
John Barton Payne Fund, 1950

This painting is a key work from 1950, the year which opened the most sig-
nificant phase of Stuart Davis' development. It typifies the thrust of this
change in its monumentality of scale and conception, simplification of
geometric pattern, and intensification of color. The assertive, emblematic
use of lettering is also new. Stuart Davis is coming more and more to be
regarded as America's greatest abstract artist of the first half of the twentieth
century. However, how he himself would have received such a judgment is
suggested by the following statement made in 1945: "...the supposed con-
tradiction between 'abstract' and 'realistic' pictures is imaginary rather than
actual. They have a basic identity of purpose to express an emotional syn-
thesis of the responses to life's subject matter."

The Country

ANDREW WYETH, American, born 1917
Tempera on panel, 40⅝ inches high by 35⅝ inches wide
The Mrs. Alfred I. duPont Fund, 1965

Wyeth's appeal is universal and it is not difficult to understand the reasons.
His subject matter is familiar, but not without psychological nuance, and is
even poignant, without being sentimental or strained. His style is lean,
brisk, and unfailingly deft in selecting the proper angle, tone, or accent. *The
Country* shows his wife, Betsy, at the window of their house at Chadds Ford,
Pennsylvania. Joseph Verner Reed describes Wyeth's "people, like his
objects, [as] solitary, watchful, autumnal," and this succinct phrase is as
close in words as one can or should get to the painting.

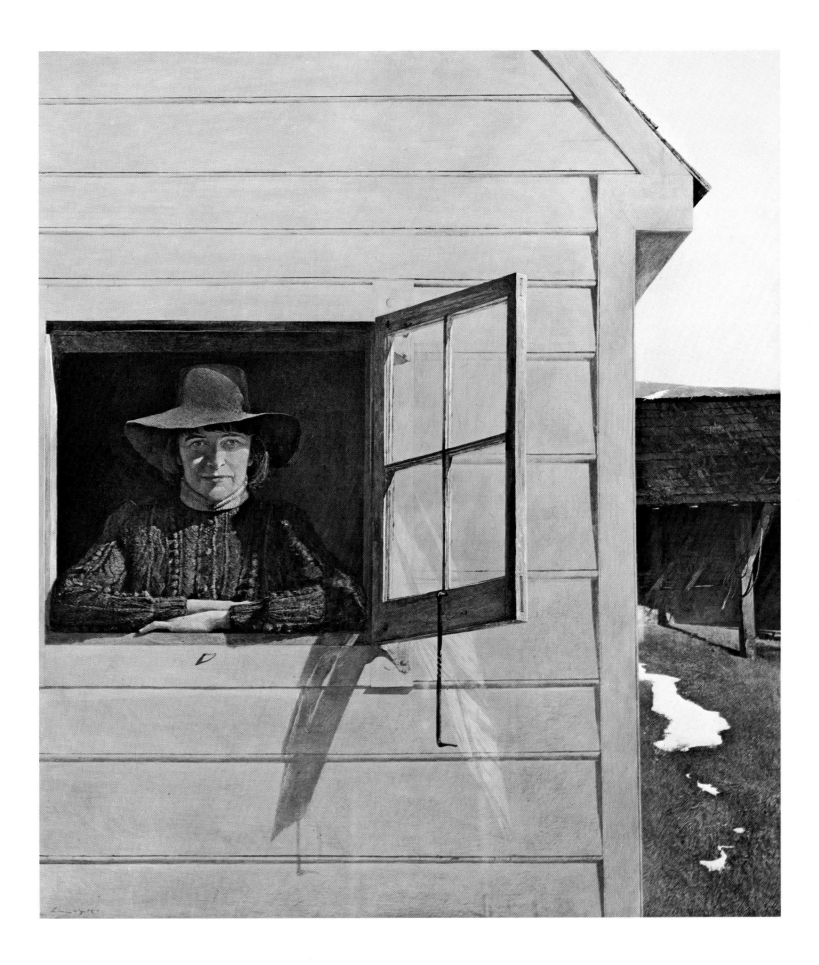

STAFF

James M. Brown, *Director of the Museum*
Pinkney L. Near, *Curator and Author*
Raymond Geary, *Designer and Production Supervisor*
George Cruger, *Editor*
Monica Hamm, *Editorial Assistant*
Ronald Jennings, *Photographer*
Katherine Wetzel, *Photographer*

This book was set in 11 on 13 point Elegante (Fototronic)
by Typographic Service, Incorporated of Philadelphia and
printed by W. M. Brown & Son, Inc. of Richmond.